THE COUNTRYSIDE
IN WATERCOLOUR
Ann Blockley

D0572307

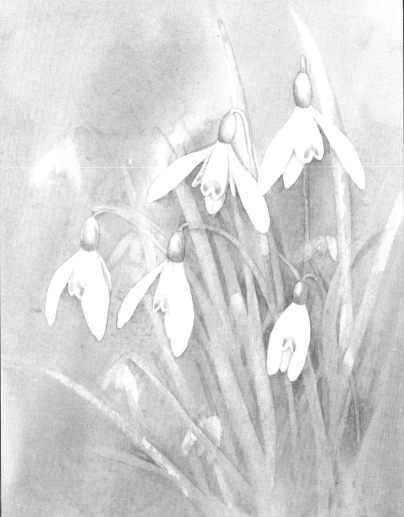

COLLINS

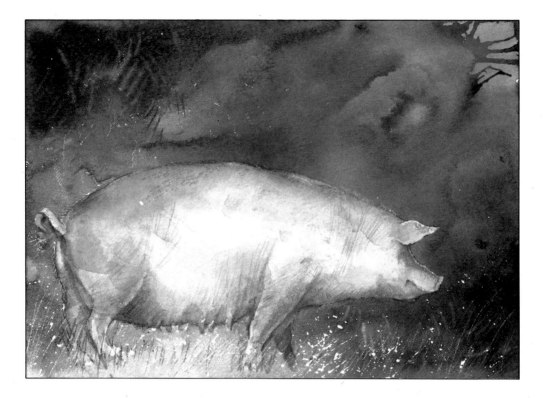

First published in 1988
by William Collins Sons & Co., Ltd
London · Glasgow · Sydney
Auckland · Toronto · Johannesburg

© Ann Blockley 1988

Filmset by Ace Filmsetting Ltd, Frome, Somerset
Colour reproduction by Bright Arts, Hong Kong
Photography by Nigel Cheffers-Heard

British Library Cataloguing in Publication Data
Blockley, Ann
 Learn to paint the countryside in
 watercolour.
 1. Watercolour landscape paintings –
 Manuals
 I. Title
 751.42′2436

ISBN 0 00 412287 9

Printed and bound in Italy
by New Interlitho SpA, Milan

CONTENTS

PORTRAIT OF AN ARTIST
ANN BLOCKLEY

Fig. 1 Ann Blockley sketching near her home

Ann Blockley was born in Lancashire, where she spent the early years of her life. She moved with her family to the Cotswolds in 1975 when her father, John Blockley, a well-known watercolourist, opened a gallery in Stow-on-the-Wold. At this point she began to develop a keen interest in painting and drawing, and spent a lot of time exploring the nearby woods, fields and farmyards for countryside subjects.

She embarked on a career in the arts by enrolling for a foundation year at the Gloucestershire College of Art and Design. At the end of this course she decided to specialize in illustration and was accepted for the BA Honours Degree course in Illustration and Graphic Design at Brighton Polytechnic. Here she developed a highly decorative and detailed method of working.

During holidays and weekends she would return to the countryside and practise a different style of work altogether: evocative watercolour paintings of flowers, animals and country artefacts, such as those seen in this book.

After graduating from Brighton in 1982 Ann Blockley immediately launched into a successful career as a freelance illustrator, and has since been commissioned to do work for books, numerous greetings cards, and giftware and packaging for many well-known high-street shops. She was invited to submit designs for a prestigious set of postage stamps depicting the four seasons of the hedgerow. She has also had work included in *Images*, the Association of Illustrators' annual, which records the best in contemporary British illustration.

Besides her career as an illustrator Ann Blockley is also a successful watercolourist. This work is widely sought and there is always a demand for her paintings in the few selected galleries where she exhibits. Many of her paintings are exhibited in the John Blockley Gallery, where she shows her limited-edition prints of countryside flowers and farm animals.

As well as painting the countryside she also cares about conserving it. With her husband she created a nature reserve in a field belonging to the cottage in which they used to live in Oxfordshire, where wild flowers were encouraged to flourish and wildlife to visit.

Ann Blockley now lives in a thatched cottage surrounded by open countryside in a tiny Gloucestershire hamlet – the perfect setting for watercolour painting.

Fig. 2 An old village pump makes an ideal subject

Fig. 3 Ann Blockley making a rapid drawing of some inquisitive geese

WHY PAINT THE COUNTRYSIDE?

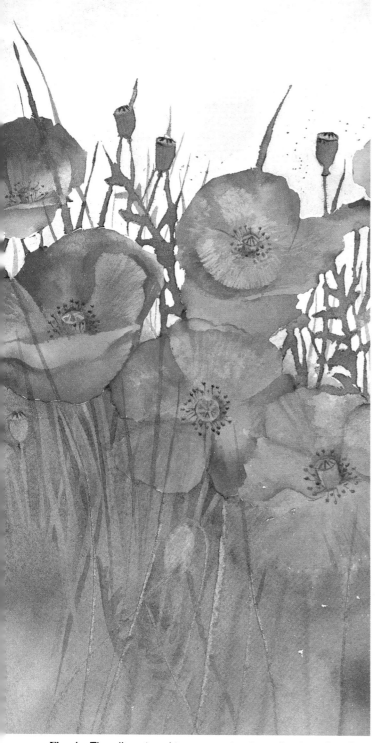

Fig. 4 The vibrant and transparent nature of watercolour is perfect for portraying these poppies

What could be more enjoyable than drawing and painting the beautiful countryside that surrounds us? What more delightful than observing the woodlands, meadows, ponds and hedgerows and the flora and fauna that inhabit them?

In setting out to record these pleasures, it is impossible not to notice how many of them are disappearing. Hedgerows are being torn out, ponds and marshes drained, and herb-rich meadows ploughed up, with the consequent depletion of the native wildlife. I believe that in order to paint the countryside with feeling you have to care passionately about conserving it. However, this book is not an exercise in nostalgia; I wish to encourage you to enjoy the countryside and record the many delights that remain. There is an infinite variety of subject matter to be found, to suit both the beginner and the more experienced painter.

My own interest is in studying the intimate details of the countryside. I love the frothy lace of cow parsley and the black and white jigsaw patterns of fat Friesians; the swaying silvery grasses and spiky thistles; the ancient hedge with its dark, gloomy interior and criss-crossed tangle of twigs, brambles and nests. I also enjoy the man-made elements of the rural scene; not the barbed wire fences and modern machinery, but the relics of a past age, now weathered and textured to look as natural as the ground they are slowly returning to. There is a potential subject for every painter in the crumbling ruins of a dry-stone wall, the flaking rust of an ancient pump or the mildewed wood of a rickety fence.

I realize how especially fortunate I am to be living in the country. Looking out of the window now, I can see a large round blackbird, his vivid beak busy amongst the clouds of creamy elderberry flowers. Through gaps in the dark mass of foliage, sherry-coloured cattle dreamily stand munching buttercups in a distant field. In the country, subjects are easy to find; in a town you may have to work a little harder to discover them, but there are still lots of possibilities if you are observant. Parks, gardens and even window boxes yield potential subjects for study, lacking only the variety of rural areas.

Why use watercolours?

I find that watercolour is an ideal medium in which to paint the countryside. Every medium has its own particular quality, and the essence of watercolour is its transparency and luminosity. Light reflects from the

white paper underneath the thin layers of paint washes to lend colours the brilliant clarity of stained glass with the light shining through it. Just because this medium uses water as its solvent does not mean that it has to be wishy-washy. The colours can be soft and subtle or rich and deep; the choice is yours.

Watercolour is a very immediate medium and painting with it is a challenging process. You will undoubtedly find that manoeuvring liquid paint, apparently with a mind of its own, is both exasperating and frustrating. When you master the techniques, however, the watercolour medium is very rewarding.

The mobility and fluidity of diluted watercolour mean that huge, silky brushes can be laden with paint and used to float and drift colours over expanses of textured paper with loose, bold strokes. In this way you can very effectively capture the open spaces and ever changing moods of the countryside. Conversely, the paint can be used in a very controlled manner, using tiny brushes to create delicate images, such as insects or wild flowers, on smooth, vellum-like paper.

Not only does watercolour have the facility to adapt to both broad and tight styles of work, but its versatility means that it can be used in other ways, too. Nothing could be more satisfying than using the traditional techniques, developed over the centuries, building up layers of translucent washes of colour. Yet due to the nature of the paint, things can easily go wrong: a drop of water or ink dropped inadvertently on to a new wash would undoubtedly ruin it. However, I have found that accidents like this can in fact be exploited and some unpredictable but exciting results achieved. I experiment in this way in order to best capture on paper all the textures of the countryside that interest me. Crumbly lichen, twisted brambles or deeply grooved tree bark might not be so eloquently described with traditional techniques.

Many people have the preconceived idea that watercolours, unlike oil paint, for example, should not be worked into, and that brush strokes should be made and then left untouched. I have the opposite attitude. I work into paint, push it around, scrape, scratch, blot and spatter to obtain the textures and patterns I want.

My use of more experimental methods means that I work mainly in the comfort and convenience of my studio. I do spend a lot of time outdoors, though, sketching on the spot. It is helpful to have first-hand experience of a subject, if possible, in order to paint it with feeling; to touch the warmth of a horse and feel the scratch of a bramble.

Developing your own style

This book is very much about my personal way of painting. I describe the various techniques available and how I apply these methods to different subjects. It is important for you to be aware, however, that these are just suggestions of ways to paint, the way that I myself choose to work; everyone must develop his or her own style. A book like this imparts technical advice and information which you must then sift through and adapt to suit your own requirements. You will need to have something to say in the first place about the subjects you see around you before you can start to translate them into paint.

Try to look at the world with the sense of discovery and curiosity of a child seeing things for the first time. I recently found the picture of a scarecrow in **fig. 5** when sorting out my attic. I remember painting it when I was seven. The cornfield was a shimmering expanse of glowing yellows and hot reds behind a dark, sombre scarecrow swaying in a summer breeze. It is an immediate and striking image that communicates straight away the sense of excitement I had felt about this scene. There is no doubt at all about what stimulated my young self to paint the picture.

The aim of the mature painter should be to retain or relearn the excitement and impact of visual discovery that comes so naturally to a child. By combining this clarity of vision with a facility in the techniques taught in this book I hope you will continue to develop your skills and to produce many successful paintings.

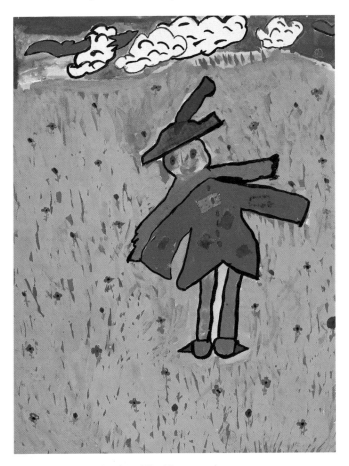

Fig. 5 Painting by Ann Blockley, aged seven

WHAT EQUIPMENT DO YOU NEED?

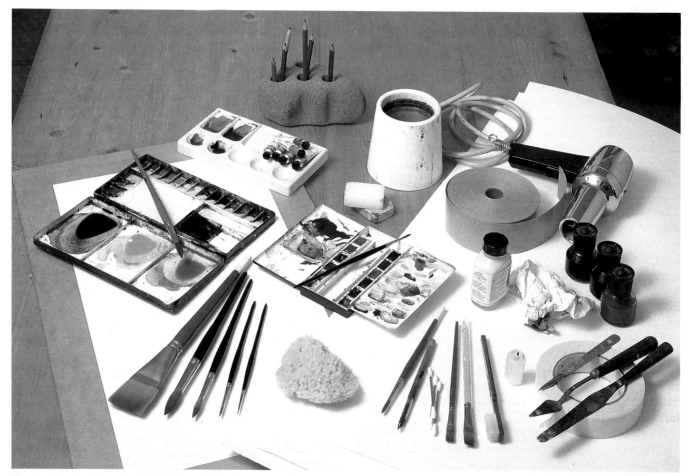

Fig. 6 A selection of materials for painting in watercolour

1	Pencils	18	Sponge
2	China palette	19	Brush for masking fluid
3	Tubes of watercolour	20	Pen and nib
4	Water pot	21	Cotton buds
5	Watercolour papers	22	Flat-topped brushes
6	Stretched paper on board	23	Old toothbrush
7	Metal palette	24	Candle
8	Plastic and putty erasers	25	Masking tape
9	Gum strip	26	Scalpel
10	Hairdryer	27	Palette knives
11	Paintbox with pans		
12	Masking fluid		
13	Paper towel		
14	Black Indian ink		
15	Coloured waterproof inks		
16	Wash brush		
17	Sable water-colour brushes		

When you visit an art shop to choose your equipment you will be confronted with an Aladdin's cave of materials. It is very easy to allow yourself to become bewildered and intimidated either into returning home empty-handed or, as more often happens, spending a fortune on items that are quite superfluous.

I would suggest that on your first shopping trip you choose a few basic essentials and then build up your collection as you gain experience and establish your own preferences. Every artist has his or her own favourite brush and colours, and in the end the choice is up to you. I can, however, offer some guidelines to help you with your initial choice of materials and equipment. You should buy the best quality that you feel you can afford; avoiding the temptation of expensive gadgetry can help to finance this.

Paint

There are two qualities of watercolour paint available: Artists' and Students'. The latter are more modestly priced and give acceptable results, although at the expense, perhaps, of some of the vibrancy, transparency and fluidity of colour – the finer qualities of watercolour, in fact. Artists' quality watercolours are more expensive but are worth investing in if you can afford to do so.

The other choice to make is between pans and tubes of paint. Pans are partially dried blocks of paint which are convenient for outdoor work and paintings on a small scale that do not involve large washes of colour. Tubes are more suitable for squeezing out and mixing large quantities of pigment, and are the kind I prefer.

If you choose pans rather than tubes of paint you will need a paintbox to hold them. You can either buy one with pans of colour included or one that has spaces for your own selection of colours to fit in. I would suggest that you choose an empty box and fill it with the colours you want rather than paying for colours you don't. If you decide to use tubes of paint, then a box like mine would be ideal (see **fig. 6**).

All the types of watercolour are available in a kaleidoscope of different hues, but in fact a wide variety of colours can be mixed from a fairly limited palette (see page 16). My first choices would be Cobalt Blue, Monestial Blue (Phthalo), Burnt Umber, Burnt Sienna, Lemon Yellow, Raw Sienna, Cadmium Red, Crimson Alizarin and Hooker's Green No. 2. You can then extend this basic palette as your requirements expand.

Brushes

Your most important purchase will be brushes; even if your budget is limited, make the cost of these a priority consideration. You will never paint masterpieces wielding children's mops and chimney sweep brushes.

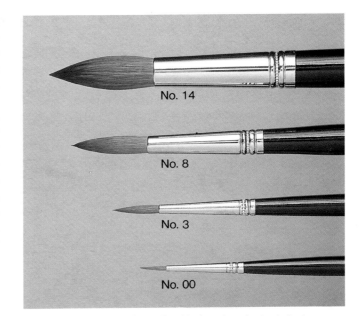

Fig. 7 A basic selection of sable brushes (actual size)

The best watercolour brushes are made from sable. These are the ones that I like to use. They are, however, the most expensive type, particularly in the large sizes, so brushes made of ox-hair or a sable/ox-hair mix are reasonable alternatives.

Brushes range in size from a minuscule No. 000 to the large No. 14. You will need only three brushes to begin with: a small size for details, a medium one for general use, and a large brush for big areas of colour. A really tiny brush is also useful if you want to do very delicate work, but bear in mind that you will only achieve fine lines if your brush has a good sharp point. I have chosen four brushes in **fig. 7**, Nos. 00, 3, 8 and 14. These should cover your requirements to begin with; you can always buy other sizes later on if you find it necessary.

Brushes are also made in different shapes, either round or flat. I use the round type for most of my work, but large flat brushes can be used for big washes and the flat chiselled kinds, like the one in **fig. 6**, are useful for making different types of marks from those obtained with round brushes.

It is important to look after your brushes. They should not be left in the water pot overnight or with the weight of the brush on the hairs as this rapidly deforms them into uselessness. The paint on the handles can flake off if the brushes are put away damp, and the hairs can go 'bushy' rather than 'pointy' if left out in bright, hot sunlight. Wash brushes thoroughly under a tap, or in clean water, making sure that the hairs in each one are free from pigment. Shake off the excess moisture, wipe the handles dry, and gently smooth the hairs to a point with your fingers. I find the best way to store brushes is in an open container with the business end upwards.

The water pot

A water pot is essential for cleaning brushes and as a reservoir from which to dilute paint. The pot should be a broad-based container, as big as possible. I've seen some people using tiny, wobbly jamjars that are simply no good at all; the water will get dirty within minutes of you starting to work and clean water is essential for clean paint.

Palettes

My palette is a slightly battered japanned metal paintbox given to me by my father. It has lots of little compartments around the edge into which paint can be squeezed, and the rest is divided into trays so that different mixes of colour can be kept separate. I like it as an object in its own right, but it is functional, too. I sometimes supplement the box with a white china palette. This too has separate wells for mixing colours in and is more easily cleaned.

Dinner plates are to be avoided unless you are mixing one large wash, as the inevitable result of using one to mix several colours is a glorious mess of mixed and wasted pigment.

Pencils

You will need a pencil to draw out the first outlines in a painting, and several different pencils if you want to use them for sketching or drawing into more complicated pictures (see page 26).

Pencils are graded from 6H, which has a very hard lead and will last for ever, to 6B, which has a very soft, dark, smudgy lead and will need frequent sharpening. The mid point between the two grades is the HB. A B pencil is a good choice for drawing in the initial guidelines for a painting, and any of the other B grades can be used for more complicated work (which I will describe in the sketching section). I find the H grades too hard for watercolour painting, although they can be used for fine detail on smooth paper.

It is inevitable that you will also need an eraser – everyone makes mistakes – but use it as little as possible when drawing out, as even gentle rubbing will change the surface of watercolour paper and affect subsequent washes of paint. The best types of eraser to use are the softest; a plastic eraser or a putty one is the most suitable.

Miscellaneous items

In **fig. 6** you will note that I have included a number of other items. I use some of these from time to time, but most are not absolutely necessary if you intend to stick strictly to traditional techniques. If, however, you are going to try out some of the more experimental ideas that I describe on pages 22–5 you will need a few extra items to supplement your basic equipment. Some of these you will probably have around the house anyway, such as candlewax, old toothbrushes, cotton buds, paper towels and a variety of sponges with different textures and hole sizes. The more specialized items, such as scalpels, a palette knife, masking tape, black Indian ink, coloured waterproof inks and masking fluid, can be found at your art shop.

Masking fluid is available as a colourless or pale yellow liquid and is used for painting on to areas of paper that you wish to protect from washes of colour. It is removed by careful rubbing with a clean fingertip after the wash is dry. I favour the tinted variety as it is easier to see where you have applied it to the paper. Before using tinted masking fluid on a new type of paper it is worth testing it on a corner as some papers can be stained slightly yellow by it, and it is not easily rubbed off soft or grainy papers – the surface can be spoiled.

As masking fluid is a rubber-based solution I would advise you not to use your best sable brushes to apply it. I use my old brushes that have been retired from front-line use or, failing this, ones made from ox-hair or imitation sable.

A hairdryer can be a useful aid to speeding up the watercolour process for impatient painters like myself. I sometimes dry off very wet washes with gentle heat, carefully applied, when the natural process is taking too long. This technique needs to be used with discretion. In most cases care should be taken not to blow the paint around the paper with the jet of air, although you may inadvertently discover interesting techniques if you allow this to happen! Care must also be taken not to eliminate any textures that the paint may have made on a rough paper. The hairdryer has a tendency to even out textures if the air is applied with too much heat or force, so hold it at least 30.5 cm (12 in) from your painting for the best results.

Paper

When painting with watercolour you will need to use paper that has been specifically made for the purpose. It needs to be absorbent enough to prevent wet paint running uncontrollably over the surface whilst not acting like blotting paper, upon which large flat washes and crisp edges would be impossible. There is a wide variety of watercolour papers; your choice should be made after considering the subject matter, technique and the effect you wish to achieve.

Watercolour papers come in three basic surfaces: Rough, Not (known as Cold Pressed in the United States) and Hot Pressed or HP. The paper samples in **fig. 8** show you examples of each type of surface. I have daubed paint on each of them to demonstrate in a

limited manner the different qualities and textures of each paper.

Rough paper, as its name implies, has a coarse, grainy, irregular surface which makes it suitable for large, loose, textured work. Whatman Rough is a very white paper with a grainy, textured surface useful for landscapes, animals and, well, grainy, textured objects!

Not paper has a light, even texture, neither too rough nor too smooth. It is the most versatile paper and is a good choice to start with, being suitable for most techniques. Bockingford is made only with a Not surface and is the paper I use for most of my painting. You should find it a useful general-purpose paper.

I use Hot Pressed paper for small or detailed illustrations and for pen or pencil work. Being smooth it does not have any 'tooth' which could interfere with delicate lines or brushwork. Waterford HP is a fine-quality smooth paper on which you can achieve a lovely, clean, flat finish with crisp edges. I use it for flower studies and objects where the background is left unpainted, as the white of this paper is natural and does not glare too much.

Georgian watercolour paper has a Not surface but is quite smooth and can be used like an HP paper, but at lower cost, for detailed flower studies. It is not, however, suitable for very wet washes or heavy techniques, being rather lightweight.

As well as being made with various surfaces, watercolour paper is available in different weights. There are two ways of expressing the weight of a paper. The first is in pounds and represents the weight of a ream (500 sheets) of Imperial size paper (76 × 56 cm or 30 × 22 in). The second is much more straightforward and is expressed as the weight in grammes of a square metre of paper (gsm). I would advise you to start working with a paper of 140 lb/300 gsm.

The lighter the weight of the paper, the thinner it is and the more it will cockle when you wet it. You will need to stretch lightweight papers (up to and including about 140 lb/300 gsm) on a thick board to give a smooth, taut surface to work on. To stretch paper, cut four strips of brown sticky paper tape (the type with a water-based adhesive) to the size of your paper edges. Soak the paper in clean water – I put mine in the bath so that it lies flat. Lift the paper by a corner, letting the excess water drip off. Lay the wet paper on your thick board and blot around the edges with a paper towel. Dampen the tape and stick it very firmly over all four edges so that it is half covering the paper and half on the board. Leave the board flat until the paper is dry.

Buy one or two sheets of different papers to begin with and you will soon discover which weight and surface suit you best. Experiment by all means, but you will probably find it easiest to stick to just a couple of papers and get to know them thoroughly.

Whatman 140 lb (290 gsm) Rough

Bockingford 250 lb (535 gsm)

Waterford 140 lb (300 gsm) HP

Georgian 72 lb (150 gsm)

Fig. 8

Sketching equipment

There are many kinds of drawing media, but, as with your painting equipment, you need no more than a few items to make a start. It is possible to start sketching with just a pencil stub and a scrap of paper, but although the versatility of a couple of different pencils cannot be over-emphasized, a greater variety of tools allows you to be more adventurous and to experiment with interesting new textures and marks.

In **fig. 9** you can see just some of the different media that are available. Each medium gives a different quality of mark – thick or thin lines, hard or soft edges, crisp or smudgy, dark or light, smooth or textured – as you will see on page 14.

Coloured pencils are useful to have on a sketching trip to make notes on a drawing as a reminder of the colours you have seen. If you buy the water-soluble type you can actually paint with them with the aid of a brush and some water. This is more practical than lugging around paints, palettes and so forth for outdoor colour sketching. For sharpening pencils I normally use a scalpel as this seems to get the sharpest point, but a pencil sharpener is more convenient.

Charcoal drawings will need to be made permanent with a fixative. This can be applied using a mouth spray, but aerosol cans are more convenient and I find they give a more even application. Putty erasers are the best way of rubbing out charcoal or removing dirty fingerprints before the drawing is fixed. They can be moulded to give fine points for rubbing out small areas.

Sketchbooks are the best way of taking paper outdoors and keeping all your drawings together. I like the spiral-bound sort as they do not fall apart when the pages are folded back. The size of sketchbook you use is a matter of personal choice, but A3 (30 × 42 cm or 11¾ × 16½ in) or A4 (30 × 21 cm or 11¾ × 8¼ in) sketchbooks are manageable sizes for most work. When working in blustery conditions a large bulldog clip is useful for holding the loose edges of your sketchbook's pages together so that they are not a nuisance.

I like to carry a little A6 (15 × 10 cm or 6 × 4 in) hard-backed sketchbook around with me all the time. It slips easily into a pocket or handbag and is useful for small sketches or doodles, not to mention the occasional shopping list. A tiny sketchbook like this also allows you to capture a drawing of an interesting face or scene unobtrusively.

Sketchbooks are available in many types of papers but a good-quality cartridge paper is fine for most purposes.

Finally, I have included my camera amongst my sketching equipment. I use photographs in close conjunction with my sketchbook as I will explain later (see page 36). Mine uses 35 mm film and gives good results, but use whatever camera you happen to have and if you don't have one at all, then stick to your sketchbook.

Fig. 9 Sketching equipment

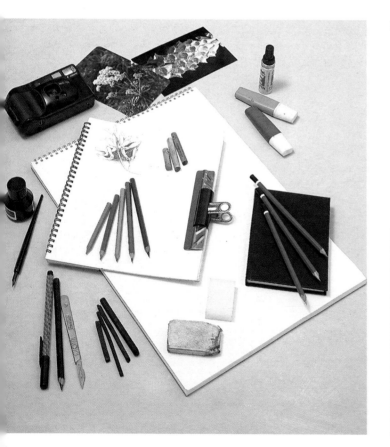

1 35 mm camera
2 Thick felt-tip pen
3 Magic markers
4 Sketchbooks
5 Pastels
6 Black Indian ink
7 Pen
8 Coloured pencils
9 Bulldog clip
10 Hard-backed pocket sketchbook
11 Pencils
12 Felt-tip pen
13 Conté pencil
14 Scalpel
15 Charcoal
16 Putty eraser
17 Plastic eraser

SKETCHING

Perhaps the most difficult part of painting for a beginner is learning the patience to train your eye before applying your hand. This is particularly true of painting the countryside. Once you have become attuned, however, it is surprising how quickly you start to discover potential subjects all around you.

Few people can store in their heads sufficiently detailed and accurate information about prospective painting subjects without recording it in some manner. Carrying and using a sketchbook is a good habit to cultivate. Ideas and information can then be recorded permanently on paper, easily accessible for reference at a later date. If you are diligent about this you will soon build up a 'reference library' of images that also acts as an aide memoire for those dreary rainy days when you are suffering from a dearth of inspiration. It is remarkable how a little book of sketches can stimulate a flow of ideas.

Sketching in public is a far less conspicuous activity than painting, with all the associated paraphernalia, and drawing media tend to be much more immediate than painting materials, which involve mixing colours and cleaning brushes.

The mechanical activity of drawing makes you look more closely and spend more time studying your subject. The information that your mind absorbs about what you are sketching is as important as the finished drawing.

Your sketches do not need to be 'finished' in the sense that they are polished and detailed, but if you get involved in a drawing then by all means allow it to progress to the stage you feel happy with. Sketches can be as free, crude or brief as you like; a visual shorthand, in fact. Even the simplest scribble can capture a fleeting impression that can later assist in the development of a painting.

Consider a sketch not as a picture for its own sake, but as a means to an end. Relax and be daring; in this case success or failure cannot be assessed simply by the beauty of the finished image. A sketching session can also be a good 'loosening up' exercise and is useful for trying out new ideas before launching into an assault on expensive watercolour paper.

Sketching in a loose manner does not, however, mean that you should work in an undisciplined or careless way, and the purpose of the drawing must always be held clearly in your mind. You are trying to capture the essence of the subject that attracted you in the first instance – the shape, tone texture, lighting or whatever.

Using different media

Try to imagine the sort of mark you might use for different subjects and think how you could best apply it in your drawings. The sinuous shape of the smooth piglet in **fig. 10** was made by drawing long continuous lines with a B pencil, whereas my black sheep (**fig. 11**) is a smudge of charcoal in a grassy meadow of short, crisp pencil lines.

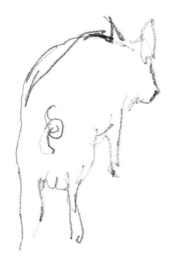

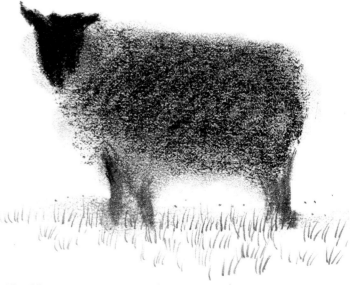

Fig. 10

Fig. 11

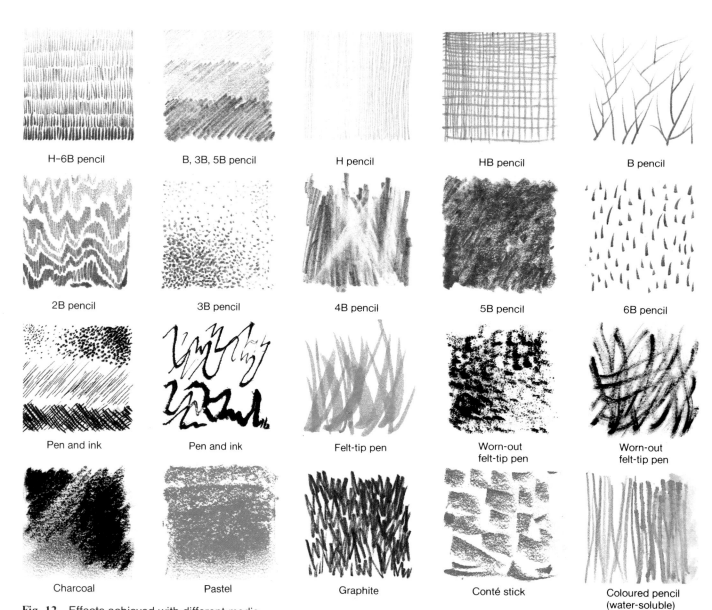

H–6B pencil	B, 3B, 5B pencil	H pencil	HB pencil	B pencil
2B pencil	3B pencil	4B pencil	5B pencil	6B pencil
Pen and ink	Pen and ink	Felt-tip pen	Worn-out felt-tip pen	Worn-out felt-tip pen
Charcoal	Pastel	Graphite	Conté stick	Coloured pencil (water-soluble)

Fig. 12 Effects achieved with different media

Fig. 12 shows you some of the qualities of mark that different media can make. It also demonstrates some of the many strokes and textures that can be created with a lead pencil. Different qualities of line can be obtained by varying the grade of pencil, the speed of the stroke and the pressure exerted on the paper. Don't feel you have to use all of the media shown here. However, to begin with it is useful to experiment with the types of line – short or long, broad or narrow – and the way they are combined. You will discover that tones and textures of infinite variety can be created. All the marks here were drawn on ordinary cartridge paper; they would be quite different on much rougher or smoother papers.

Photography

I must emphasize from the start that I consider photographs a reliable back-up to the sketchbook but not, in any sense, a substitute for one. You will never observe as much about your subject through the lens of a camera or from the resultant two-dimensional snapshot as you will from looking, drawing and remembering the processes involved in creating that sketch.

The camera is, however, a very useful tool when time does not allow a full drawing. A photograph can supplement a hasty sketch, providing information about colour, texture and composition. The lens allows you to record animals, birds and insects that cannot be expected to wait for an artist's sluggish hand. It can capture a single moment in time, freeze a poppy's transient petals, a fleeting shadow or fluttering leaf.

When using a photograph for reference you will only reap the full benefit if it is one you have taken yourself. Use sketches and particularly photographs as points of departures for your paintings; a religiously copied photograph is invariably wooden and lifeless.

14

Fig. 13 Even simple sketches can catch fleeting expressions

TRADITIONAL TECHNIQUES

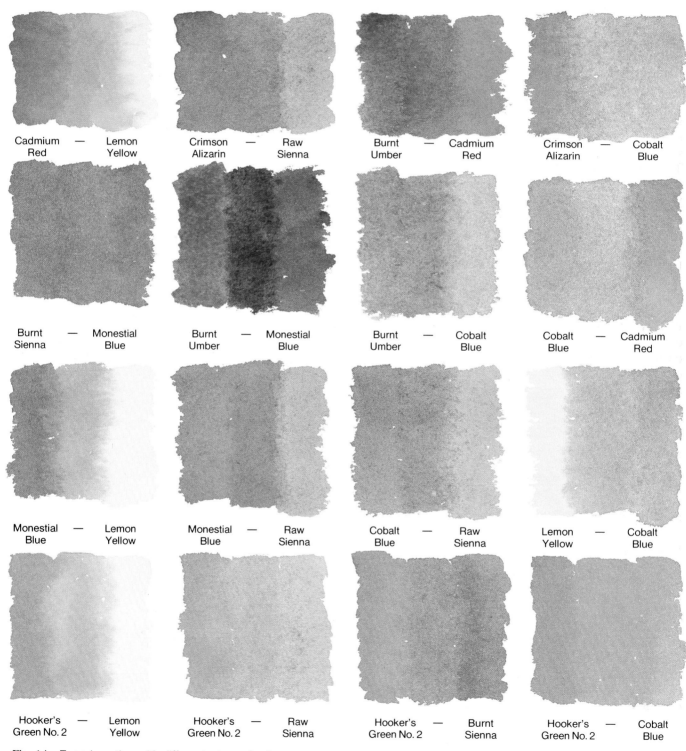

| Cadmium — Lemon | Crimson — Raw | Burnt — Cadmium | Crimson — Cobalt |
| Red Yellow | Alizarin Sienna | Umber Red | Alizarin Blue |

| Burnt — Monestial | Burnt — Monestial | Burnt — Cobalt | Cobalt — Cadmium |
| Sienna Blue | Umber Blue | Umber Blue | Blue Red |

| Monestial — Lemon | Monestial — Raw | Cobalt — Raw | Lemon — Cobalt |
| Blue Yellow | Blue Sienna | Blue Sienna | Yellow Blue |

| Hooker's — Lemon | Hooker's — Raw | Hooker's — Burnt | Hooker's — Cobalt |
| Green No. 2 Yellow | Green No. 2 Sienna | Green No. 2 Sienna | Green No. 2 Blue |

Fig. 14 Experimenting with different mixes of colour

16

Mixing colour

One of the most exciting but confusing aspects of painting in any medium is the immense spectrum of colours available. The excitement of such an endless variety of hues, brilliant and vibrant or soft, dreamy and subtle, is soon tempered by the confusion that such a choice brings!

The easiest way to narrow down the area of colour within which you are going to work is to appraise the overall colour of your subject and to pick the tube (or pan) of paint you feel is closest to it. If you were painting a leaf, for example, you might start by selecting a tube of Hooker's Green. Study the leaf more carefully and decide exactly what green it is. If it is a young spring leaf, the addition of some yellow paint would give you its crisp, sharp colour. A touch of Cobalt Blue would give you the soft, smoky blue-green of a conifer. The variations of colour within the subject are obtained by carefully varying the proportions of pigment you add to the base colour.

By experimenting with different mixes of paint as in **fig. 14** you will begin to learn how the colours in your palette combine together. Not all combinations are pleasing – certain colours become very muddy when mixed together. In the space available here I can show you only a few of the hues that I like to use.

The bottom row of **fig. 14** shows variations of green mixed in the manner described above, taking a basic colour and modifying it with a tint of another. I have chosen to demonstrate some of the shades of green that can be obtained as this colour occurs in many countryside subjects, but other pigments can be modified in exactly the same way.

Note that greens can also be made from mixtures of different blues and yellows. The rest of **fig. 14** shows some mixtures made with combinations of all the basic colours in the palette listed on page 9. See how it is possible to obtain both bright, vibrant hues and rich, subtle, earthy shades – the warm russets, misty greys and soft browns of the countryside.

Cobalt Blue is a good base from which to mix all types of grey, whether browny mushroom grey or a more purple grey. Note how very dark, strong mixtures of paint can be blended to approach black. They carry subtle undertones of colour and I use them to give more expression and depth than pure black. If you look closely at a blackberry it actually has a purplish bloom, and a menacing black cloud is really a dark inky blue.

To make these colour samples you should choose the two tubes or pans of paint you wish to use, then dilute each to a milky consistency. Brush a stripe of one colour on to your paper. Clean the brush thoroughly and paint a stripe of the second colour parallel and 1 cm (½ in) from the first. Before the stripes are dry, mix some of the two pigments together on your palette and paint a

third stripe between the first two, so that all three stripes merge together. If you label the first and second stripes you will have a permanent record of the combination these two colours make.

I have discussed mixing only two colours together as I think this is enough to cope with at first. Obviously the choice of combinations widens alarmingly when using three or more. When you experiment with several base colours, avoid mixing them in equal quantities as they can soon become muddy. I tend to use two main colours and add small dabs of others.

Laying a flat wash

The single most important process in watercolour painting is the wash, a thin, transparent layer of colour covering an area of paper. You will nearly always start a painting with a wash as it makes sense to begin with the large areas of colour and work down to the smaller detail as the picture develops.

Although it is rarely necessary to lay a completely perfect area of even colour, practising doing it is a sound way to learn to control paint (**fig. 15**). To lay a flat wash you should start by mixing plenty of paint on your palette as you will not be able to stop halfway through to mix more if you run out. You should always use the largest brush practical in relation to the area the wash is to cover.

Dilute your paint with clean water until it is quite liquid. Try the mixture on a piece of scrap paper to check that it is the tone of colour you require, remembering that it will be paler when dry than when wet. If it is too dark, add more water; if too light, add more paint.

Dip your brush into this pool of paint, ensuring that it is well charged with pigment but not dripping. Brush

Fig. 15 A flat wash

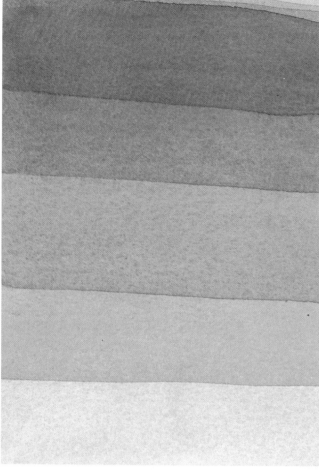

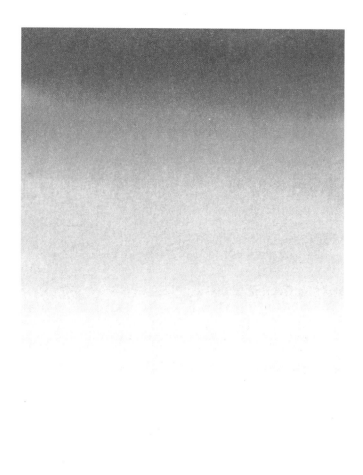

Fig. 16 An overlaid wash

Fig. 17 A graded wash

the colour horizontally across the top of the paper from left to right. Immediately paint a similar strip below the first, slightly overlapping it. Gradually move down the paper, adding more paint to your brush as required. Always refill your brush before starting a strip rather than halfway across. It is important not to move too slowly otherwise each strip will dry into hard lines. It is sometimes useful to tilt your board of stretched paper slightly to help the strips of wet paint merge into each other evenly. Eventually you should have a rectangle of perfect flat colour, but if not, do not despair – it does take practice!

Overlaying washes to change the tone

When laying a flat wash it is possible to control the depth of colour by varying the amount of water you add to the paint. By adding more water the wash will become paler. This is the way I tend to work as it seems to allow the white paper to shine cleanly through the paint.

There is, however, another way to achieve different tones of a colour (**fig. 16**). To demonstrate this for your-

self, paint a flat wash and leave it until it is completely dry. Then paint an identical wash of colour over the first, but leaving a strip of the original untouched. If you repeat this process several times you will see that the colour builds up, becoming darker with each layer of wash. I consider that five layers of a wash are the practical maximum before the luminosity of the colour is lost, further applications becoming muddy and indiscernible.

Graded washes

As with the flat wash, it is unlikely that you will ever need to lay a perfectly graded wash, starting with the darkest tone and shading gradually and evenly to the palest tint (**fig. 17**). This is quite fortunate as it is a very difficult finish to achieve! In fact, I do not feel that I have ever managed it myself very successfully.

Perfection aside, a painting will often need areas of graded colour and so it is useful to practise the technique. Prepare a strong mix of colour and make horizontal brush strokes as you did with the flat wash, but this time the paint should be diluted a little with each

Fig. 18

strip so that the wash gradually becomes paler as you work down the paper. Alternatively, you can begin with a pale colour and add pigment for each strip to make a wash that grades from light to dark.

Fig. 18 shows a very simple mountain landscape painted using a combination of the above techniques. A slightly graded wash was painted over the paper and allowed to dry. Colour was then gradually built up in layers at the bottom of the paper to create the shape of the mountains. Note how the palest colours recede and the dark tones come forward.

Streaky washes

Fortunately for us the streaky, uneven wash is much more likely to be of use than the perfectly flat or graded ones.

There are also an infinite number of permutations of the streaky wash: alternating pale and dark strips; uneven spacings; or slanting strokes rather than the formal horizontal ones. You can of course vary the colours as well as the tones as you work. **Fig. 19** shows an example of such a wash.

Fig. 19 A streaky wash

Fig. 20

Lifting colour

Colour can be lifted out of a damp wash by resting a clean, moist brush on the paper and moving it firmly across in the required direction to absorb the still-damp paint. If the brush is too wet the water will run into the wash on the paper with unpredictable results. The drier the wash on the paper, the cleaner and sharper the mark lifted will be. If the paper is too wet the paint will merge back into place again and you will just have spoiled the wash. You need to wait until the point when the shine of the water is just disappearing from the surface of the paper.

The little landscape sketch in **fig. 20** shows this process used on the sky where streaks of light have been lifted out of a flat wash. The tree and ground were added at the bottom with darker washes. I could have used the same technique to lift out a small, pale moon in the sky with a circular movement of the brush.

Wet-into-wet techniques

Up until this point, all the processes described and demonstrated have been painted on to dry paper. If you paint on to wet paper or into a wet wash, quite different results can be achieved, with soft blurred edges and unexpected subtleties of tone. Paint spreads out on the paper before you in a manner you can never quite predict. The way it reacts depends on various factors, such as timing, firmness of brush strokes and the wetness of paper, brush and paint. With experience you can judge these factors and exert some degree of control, but you will inevitably get the occasional surprise of an unexpected effect which can sometimes irritate, but often delight.

In **fig. 21** I first dampened the paper with clean water, then vigorously brushed Crimson Alizarin over half of the area, letting it flood over the damp paper. Using another brush that I had previously loaded with Lemon Yellow, I brushed colour over the other half of the paper, letting the two colours mingle and spread together in the middle. When these first washes had dried a little to the stage where the shine of the water had just disappeared, I brushed two or three light strokes of slightly darker crimson paint into the first

Fig. 21 Wet-into-wet technique

Fig. 22

wash of red, allowing the colour to blend softly into the background.

Although the overall effect appears quite random, a great deal of judgement must be used in this exercise – the colours will not, for instance, merge so successfully if one colour is more dilute than the other. Similarly, if the second application of red paint is brushed in when the paper is too wet or too dry, the whole wash can easily be ruined. Judgement can only come with experience, so keep practising!

When you start to use both wet- and dry-paper processes in your painting you become aware of the importance of different edge values. Some artists paint with hard, crisp edges throughout their painting to create a very clean, economical look. Other artists always use wet-into-wet techniques which lend a soft, romantic air to their work. A combination of both processes is the most true-to-life way of painting (**fig. 22**). Look at the countryside: you will see both soft, misty clouds and sharply graphic trees, but usually both clouds and trees have a mixture of soft and hard edges.

In **fig. 23** I have painted various shapes. They are drawn as flowers just for fun, but it is the edge values that I am demonstrating – the subject is immaterial. The red shape was painted by brushing paint on to damp paper, giving soft, furry edges. If the paper had been very wet the shape of the flower would have disappeared into an indistinguishable blur, which could be the basis for further work (see **fig. 58** on page 38). I painted in the centre of the red flower by lightly touching the almost dry paper with the tip of the brush to make a soft but defined circle.

The blue flower was painted on paper that had been dampened in one patch, but left dry elsewhere. The paint has blurred on the damp patch, but stayed crisp on the dry area. When the work was still quite wet I touched the centre as before, but with yellow paint; I could have used plain water in the same way. See how the paint has spread out in a star effect.

The yellow flower was painted on dry paper and so is completely hard-edged. I made the centre in two stages, first touching it with colour when the paint was still wet, so that it blurred fuzzily, then touching it again when virtually dry to give a darker, more defined centre.

Brush strokes

So far you will have used large brushes for painting the different washes, although naturally you would use a smaller brush for tiny areas of wash.

Brush marks can have different qualities depending on how you load the brush with pigment and how it is applied to the paper. If the brush is only just dampened with paint and then dragged quickly across the paper you will get a ragged, textured effect as in **fig. 23a**. This

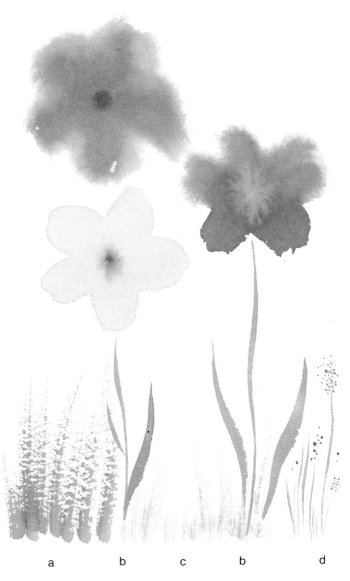

a b c b d

Fig. 23

mark can represent all sorts of surfaces – rough tree bark or shale and stones, for example.

Fig. 23b shows the sort of lines that can be obtained by varying the pressure of your brush. Here I have taken a laden brush and moved the brush point across the paper, touching it lightly at first, gradually increasing the pressure, then decreasing the pressure again. The resulting line varies in thickness as the pressure changes.

You can also load your brush with paint and then flatten the point with your fingertips into a spread-out spatula shape, so that there is very little paint remaining (a rather messy process, I am afraid). By very gently stroking the paper with the tips of the hairs you will achieve a fine combed effect as in **fig. 23c**, which is very useful for rendering animal hair and fur.

Fig. 23d shows the very fine lines you can obtain with the sharp point of a tiny brush, either by moving it across the paper as before, or by stippling to obtain dots of colour – that is, touching the paper lightly with the tip of the brush to leave small marks.

21

EXPERIMENTAL PROCESSES

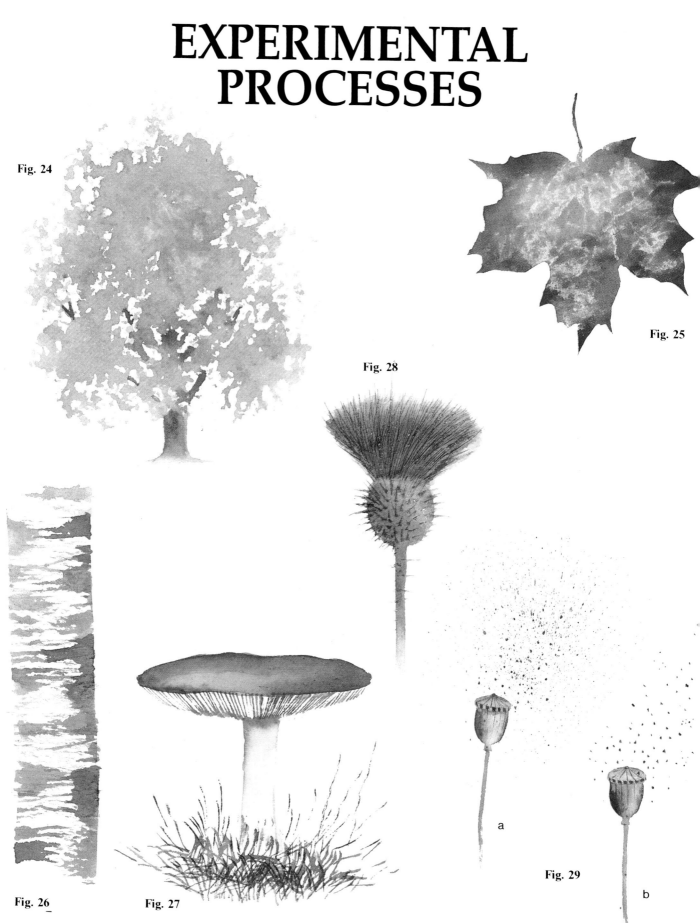

Fig. 24

Fig. 25

Fig. 28

Fig. 26

Fig. 27

Fig. 29

a

b

22

When you have mastered the traditional techniques that form the basis of all watercolour painting, you may wish to start experimenting with less conventional processes. Once you have learnt the 'rules' you can choose to break them, and start to move paint about, exploiting its qualities. The examples in this chapter are meant to serve as starting points only, and are intended to spark off ideas of your own.

Printing

All kinds of textures can be created by applying paint to the surface of different objects or materials and printing with them.

To reproduce the effect shown in **fig. 24** you should take a natural sponge and brush it with plenty of paint. The sponge will soak up a lot of colour. Press the painted sponge firmly on to the paper. The more pressure you exert, the crisper and more defined will be the resulting image. If you apply the sponge several times without adding more paint, the image will become more faded, giving different tones of colour. Overlapping the prints randomly and turning the sponge with each application prevents the shapes becoming repetitive. Try using other sponges with different textures; hard, holey ones resembling Swiss cheese might give a pattern that looks like pebbles, for instance.

Crumpled paper towels dipped in paint also give interesting effects. The tips of cotton buds make small circular marks useful for portraying berries or the centres of flowers. Try anything that you feel will make the texture you need to describe an area of your painting.

Creating patterns in a wash

It is possible to create pale shapes and patterns within a wash by pressing absorbent objects and materials into it. This is really the reverse of printing and anything that makes a useful pattern can be used. In **fig. 25** I have used a paper towel.

Mix and lay down a wet-into-wet wash of one or several colours. Do not dilute the paint too much as the pale texture lifted out is usually most effective against a darkish ground. When the wash has dried to the point just before the shine has disappeared from the surface of the paper, press the object you have chosen into the wash gently so that the pattern is created as the paint is lifted away.

The palette knife

A palette knife can create some interesting effects. Mix some colour on your palette, then take your palette knife and draw it sideways through the paint so that it coats the lower edge of the knife. Place the edge of the blade at a 45-degree angle to your paper and drag the knife sideways whilst pressing down firmly. The paint will be fairly solid at the start of the stroke, becoming ragged and patchy as the paint runs out. **Fig. 26** shows this process executed twice, first from right to left and then from the opposite direction so the two strokes meet in the middle. I find this a particularly effective way of describing tree trunks, but I can also imagine it being used to portray disturbed reflections in a river.

The flat-topped brush

The edge of a chisel-shaped brush will make short lines which vary in quality – thin and crisp, thick and soft, broken and uneven. Dampen the brush and make sure the tip forms a thin, neat edge, using your fingertips to form it if necessary. Dip just the end of the bristles into the paint and then, holding the brush perpendicular to the paper, lightly touch the surface with the brush. By repeating the resulting mark you can build up textures like straw or hair, for instance, either using the same mix of paint throughout or varying the tone or colour.

In **fig. 27** I have painted the gills of the toadstool and the short, coarse grass using this technique. Note how some of the marks are narrower than others where I have flattened the brush to give a thinner line.

The scalpel

One way of creating needle-fine lines is by using a scalpel. Put a wash of colour on to the paper and immediately draw lines with the point of a scalpel, lightly scoring the surface of the paper so that the wet paint soaks into the crevice to make a dark line. If you drag the scalpel beyond the area of wash you will extend and taper the line as I have done in the thistle head in **fig. 28**.

When the paint is absolutely dry you can use a similar technique, but in reverse, to scrape paint from a wash in dots or lines. The crispness of the line depends on how smooth or rough the paper is and on the sharpness of the scalpel.

Spattering

Load a paintbrush with plenty of liquid paint and transfer it to an old toothbrush (not too decrepit as there must still be spring in the bristles). Hold the length of the toothbrush at a 45-degree angle to the paper and use the blade of a scalpel or palette knife to stroke the surface of the toothbrush gently towards you so that specks of paint spatter out over the paper.

The strokes of the blade can be gentle or firm to vary the effect from a delicate spatter to a vigorous spray of paint. Large areas can be treated in this way by applying paint until an overall texture is built up, but the method can also be used in small areas, such as the poppy seeds bursting from the capsule in **fig. 29a**. The

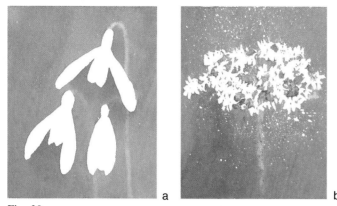

Fig. 30

spray of fine dots is much more vigorous and spontaneous than the mechanical and static results obtained in **fig. 29b** where the seeds were painted in with the point of a brush.

Masking fluid

One very effective method of obtaining a hard-edged white shape within a wash, as shown in **fig. 30a**, is by the use of masking fluid. Paint the fluid into the required shape on to the blank paper and when dry, paint your wash over the top. When the wash is completely dry, gently rub away the masking fluid with a clean finger to reveal the crisp white paper beneath. You can then paint into this as required. The advantage of this technique over simply painting around the white shape is that the wash flows uninterrupted over the whole area without changing direction in a 'halo' around the shape.

If you want a less harsh image, as in **fig. 30b**, paint your shape in masking fluid again and when dry, rub the surface very gently with your finger. The purpose here is to break the edges and tear small holes in the layer of fluid. When the wash has been applied and has dried, rub the rest of the masking fluid skin away as before and you will see that the paint has penetrated these breaks to give speckled textures and ragged edges.

The shower of white dots relieving the background in **fig. 30b** was made by spattering masking fluid with a toothbrush as previously described and then applying the wash as before.

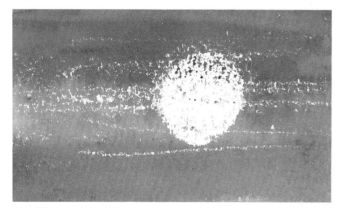

Fig. 31

Wax

Use the stub of a candle to draw on to your paper, alternately dragging lightly in places and pressing heavily in others. The paper needs to be quite rough for the best effects. Paint a wash of colour over the paper and the wax will resist the paint to give the grainy, dragged effect shown in **fig. 31**.

Fig. 32 *(above)* **Fig. 33** *(below)*

Masking tape

If you lay masking tape on to paper and paint over it, the tape will resist the paint and leave white paper when removed. It is advisable to try the tape out first on a corner of your paper to ensure that the surface does not tear or spoil. In **fig. 32a** I have torn the tape into ragged-edged strips. You could leave the straight edges if you want a ruler-straight line, but it is unlikely that you will find this perfection of line in the countryside.

The tape needs to be smoothed down firmly so that paint does not seep under the edges. Note that sometimes, where the strips of tape overlap, the paint does tend to seep underneath, leaving lines, so make doubly sure that these edges are firmly rubbed down with a

fingernail to avoid this. I rather like this effect, however, and occasionally deliberately allow it to happen.

In a similar manner I have deliberately exploited the tendency paint has to flood underneath loosely stuck tape in **fig. 32b**. In this example I painted a wash of colour over the whole area and applied the tape loosely when this was dry. The subsequent wash has crept under the edges and made blotchy, uneven patterns with pale shapes of the original wash showing in the places where the tape adhered properly.

Blowing

Drop some liquid paint on to your paper, then tilt it so that the wet paint dribbles in twiggy, meandering lines. If you gently blow the beads of paint at the ends of these lines they will split and change direction and look exactly like branches or grasses, the lines gradually becoming narrower and paler as the beads diminish. **Fig. 33** shows this process applied with dark ink, the background being made with ink spattered by a toothbrush.

Waterproof ink

Waterproof ink and water are, obviously, incompatible. You can exploit this to make interesting granular textures. Brush a wet watercolour wash on to your paper and drop globules of waterproof ink into the paint. Tilt and move the paper to coax the ink and watercolour to coagulate and split into fragments of colour and pattern.

Fig. 34 shows black Indian ink dropped into a wash of Olive Green, and for me the resulting textures instantly conjure up images of newts, lizards and mildewed walls. **Fig. 35** is a wash of green paint with Indian and various coloured inks dropped in. This suggests to me lichen-covered gravestones and mossy rocks. **Fig. 36** has a background of pink watercolour with pink and blue inks added. The result is prettier and less morbid than the previous experiments!

The very nature of these experimental methods means that only a limited degree of control can be maintained. The overall effect is planned, but it is the element of randomness in the way the paint flows that adds interest, and in a fully developed painting the textures, lines and patterns created would rarely be left completely untouched. To make these effects meaningful and to integrate them into the painting you will usually need to modify, extend and work into them.

There are pitfalls to be aware of when using these techniques. If applied to excess the finished painting can appear gimmicky and contrived. Used carefully, however, they will add to your pleasure in creating the picture and give extra interest to the end result.

Fig. 34

Fig. 35 (*above*) Fig. 36 (*below*)

DAISIES
WORKING FROM A SKETCH

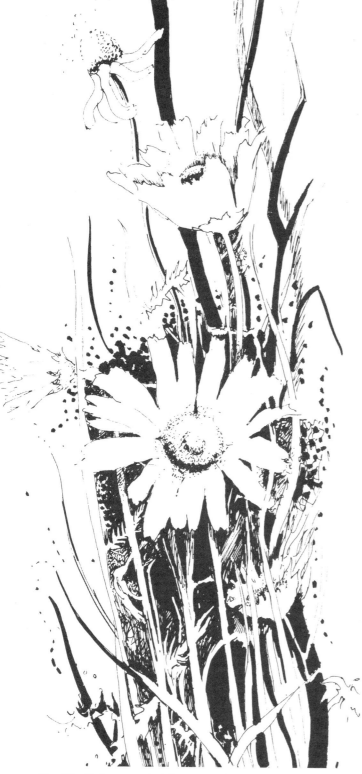

Fig. 37 Reference sketch

During the spring and summer the hedges, fields and woods present an infinite variety of possible subjects for paintings. Clusters of wild flowers spring up in every corner. Even in the town you will see dandelions fighting through cracks in the pavement and rosebay willowherb flooding building sites and wasteland. Every group has fascinating possibilities in terms of patterns, tones and colours. Look closely at them. The more keenly you observe, the more complex the designs within them will appear.

I saw this group of daisies in the corner of a Gloucestershire meadow. The flower heads floated like pale butterflies above the swaying grasses. I was struck by the delicacy of the soft greens and whites. After this initial impact I looked more carefully and noted the intricate interweavings of the sinuous fronds, stalks and petals, almost like a textile design.

It was a hot, sticky afternoon and watercolour is a difficult medium in which to work under such conditions. Paint dries too quickly and flies are irresistibly drawn to land in your nice clean wash. I decided to work in the studio, but because it was not so much the daisies themselves that interested me as the textures and patterns between them, I needed to make a sketch on the spot (**fig. 37**). I wanted to capture the atmosphere and informality of the group and was not interested in the sort of formal, composed arrangement that tends to occur when painting picked flowers.

I crouched down to the level of the plants and established the main shapes and patterns with brush and ink, putting in a few details with a pen and paying particular attention to the daisies' eyes. Then, after picking one or two flowers and grasses for reference, I returned home to paint in comfort.

I chose a relatively smooth paper (Whatman 90 lb HP) as I intended to limit my colours and use pencil shading and I did not want the coarse, grainy effect of graphite on rough paper. Using a pencil in conjunction with watercolour forces you to be concise about what you want to portray, unlike working with a heavy wash that can hide a multitude of badly drawn shapes. For those who find working with detail difficult, a pencil is often easier to handle than a small brush and it is also a useful tool for encouraging you to concentrate on tone, shape and texture rather than just colour.

I drew the petal shapes very faintly with a sharp but soft B pencil. When using pencil you must remember that it is not possible to erase marks once they are painted over, so it is vital to avoid hard, unnatural lines around flowers or objects.

I then mixed two very dilute washes of Cobalt Blue and Lemon Yellow, the first with more blue in it, for the central shadowy area, and the second more yellow for the sunlit edges. Drifting the two washes on to the paper, I let them merge together, being careful to leave the flowers white by painting around them.

When the wash was completely dry I used the B pencil again delicately to strengthen and define the shape of the daisies by shading with soft strokes in between the petals, leaves and intertwined stems. You should not be too literal about the shapes you create when painting in this way. I drew a pattern of almost geometrical shapes to get the effect I wanted.

I concentrated the pencil work around the central flower, giving this area the most detail and using a 2B pencil for the darker tones. By treating the rest of the painting quite sketchily, I ensured that it would not detract from this focal point.

Turning to the daisies, I painted the centres with a smudge of Cadmium Yellow restrained with a hint of Hooker's Green and touches of Raw Sienna. When this was dry, using a soft pencil, I stippled in the eye of the main daisy with the texture I had recorded in my sketch, leaving the other flowers untouched.

When painting white flowers there is no need for you to use white paint. The crisp white of the paper is so much cleaner and purer than paint could ever be. To give the flowers depth, however, it is necessary to add a little colour, so I brushed a pale solution of Cobalt Blue on the parts of the flower that I wanted to recede.

Fig. 38 Pencil and watercolour drawing based on the sketch opposite

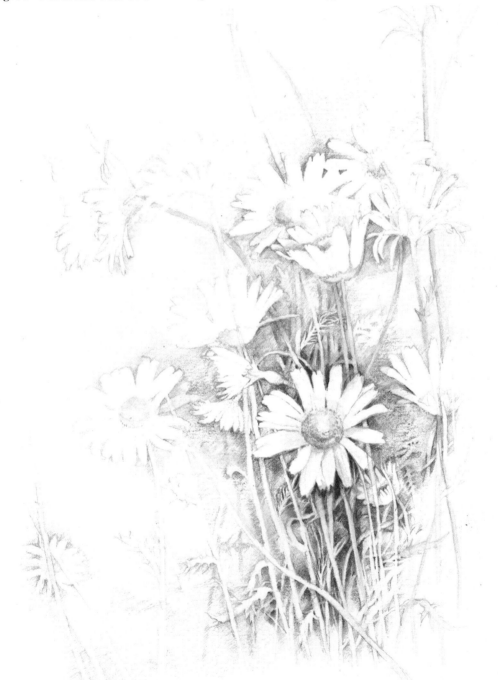

NOTES ON TREES

Trees throw a cloak of colour and pattern over every season, providing us with painting subjects all the year round. In winter there is the deciduous trees' lattice-work of bare branches relieved by dramatic evergreen conifers. In spring the soft haze of buds and blossom appears, which develops into a mantle of summer foliage in every shade of green. This in turn changes in autumn to a rich patchwork of browns, golden yellows and russet reds.

There are so many types of leaf that it would be impossible to list here all the colour combinations that I would use to paint every variety. A point to note when colouring evergreens is that they are not, of course, always green as the name implies, but more often blue-toned or golden.

Each type of tree also varies in form, from the cascading willow tree to the upright poplar. I suggest you study trees in winter first as the shape, structure and growth pattern of branches are clearest at this time of year.

Fig. 39 shows a sketch I made one winter of an old stumpy oak tree. It was drawn with a soft 4B pencil. The tree's wide trunk was covered with thick clots and clumps of ivy, which I indicated with dark dots over scribbled shading. The trunk divided into finger-like branches pointing skywards, then dwindled into spidery twigs. I drew these lines by starting with heavy pressure on the pencil, then easing off to a fragile trail.

I developed a painting from this sketch (**fig. 40**), depicting the tree as a silhouetted shape against a soft pink sky. I painted the sky first with a pale streaky wash of Cadmium Red and Lemon Yellow. The circular sun and the wisps of clouds were lifted out using a moist, clean brush. I then lightly retinted part of the sun so that some cloudy streaks appeared to float in front of it.

When this was dry I drew a faint outline of the grassy bank, tree trunk and large branches, then filled in this shape with wet-into-wet washes of greys and browns, mixed from combinations of Burnt Umber, Monestial Blue and Hooker's Green. I painted the tree and bank as a continual wash to emphasize that the tree was growing out of the ground and was not just placed on top of it. A tree will never look natural if painted separately from the ground in which it stands. Finally, I drew in the spidery branches, using the same colour as before, with a pen and nib, ensuring that the ends dwindled to nothing rather than breaking off bluntly.

Fig. 39

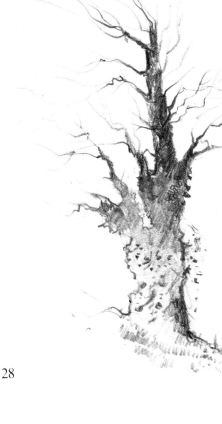

Fig. 40

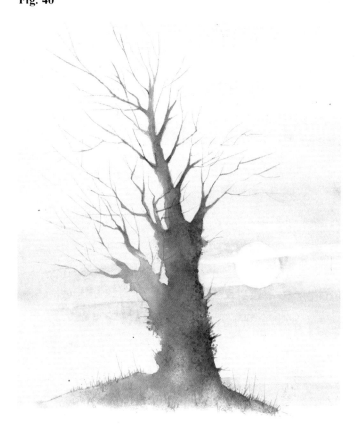

Once you have become familiar with winter trees you could advance to leafy summer trees. **Fig. 41** shows a sketch of one contrasted against a dead tree, which demonstrates how the structure is just visible between the leafy clumps.

The other important aspect of tree painting is depicting the qualities of different sorts of bark. Again, the surface of each type of tree has individual characteristics: smooth or scaly, wrinkled or peeling.

The drawing of the willow tree in **fig. 42** was made chiefly to record the deeply ridged and furrowed bark. I used a 5B pencil to block out the branch shapes, then drew heavy linear marks to build up the dark texture of the bark. Some of the light grooves were made by rubbing out pale areas with a plastic eraser.

Fig. 43 demonstrates one way of painting a bark texture like this. First I laid a wash of Burnt Umber mixed with traces of Hooker's Green. I immediately brushed a more concentrated mix of the same colours down the edges, letting the different tones merge together. Whilst this was still wet I turned my paintbrush upside down and used the pointed tip of the handle to scrape roughly vertical lines through the paint, spacing them unevenly and overlapping them in places. This satisfactorily described the grooved wood by depositing dark lines in some areas and scraping paint off to leave pale marks elsewhere. Finally, I added some patches of virtually undiluted Burnt Umber to give the impression of the deep, pitted holes characteristic of willow bark.

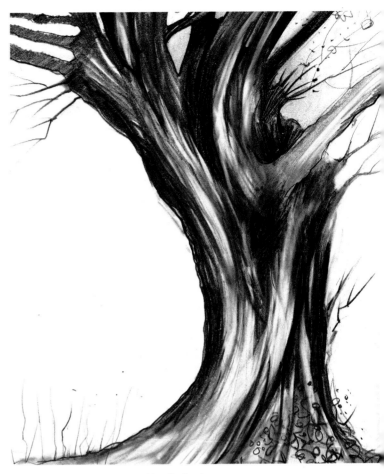

Fig. 41

Fig. 42 (*above*) **Fig. 43** (*below*)

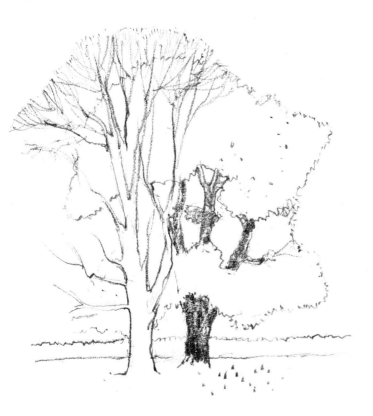

EXERCISE ONE
HENS

Every morning I walk down to our field to feed the hens. Invariably I linger to watch the endless patterns and pictures that their bodies make as they move around continually, pecking, scratching and squabbling over choice morsels of grain or grass. I sit and draw thumbnail sketches (**fig. 44**) of the ever changing compositions they create to a cacophony of clucks and squawks.

Our hens are Marans. Through half-closed eyes their barred black and white plumage becomes a tangled mass of lacy charcoal flounces; with their angry golden eyes and scarlet faces, they prove irresistible subjects.

This dash of scarlet is significant. One of the indications that a hen is coming into lay is the change in the colour of her comb and wattles from pink to red. From a painter's point of view, however, this metamorphosis provides a bright punctuation against an otherwise sombre autumn background. Always look out for accents of colour like this to enliven a painting.

There are many types of poultry with endless wonderful variations of shape, pattern and colour. The Light Sussex, for example, has a delicate black doily about its snowy shoulders. The Welsummer sports jewel-like plumage in hues of azure and turquoise, whilst the Buff Orpington is a comfortable cloud of creamy down.

I like to paint subjects that I am familiar with and which are freely available to sketch. With poultry I need to wander only a short distance to see how a wing or a foot is structured. It is important for you to get to know and understand a subject thoroughly through looking and drawing before attempting to paint it.

In the sketch on which I chose to base my painting I captured a moment when all the hens were turning their heads to stare curiously at someone or something at the edge of their field. My intention was to keep the viewer of the painting guessing as to what the chickens found so absorbing. Was it a parading cockerel, an intruder, or a rival hen? I wanted the picture to tell a story. Visually, I also wanted to create pleasing positive and negative shapes and to make the textures within those shapes interesting and evocative.

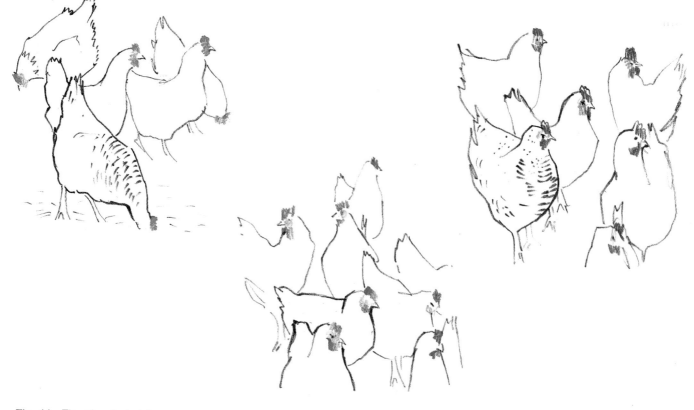

Fig. 44 Thumbnail sketches

First stage I drew the overall outline of the birds with an HB pencil on Bockingford 140 lb paper. I then brushed masking fluid within the shapes of the hens, being particularly careful as I painted the smaller areas of the heads and feet. Using a pen and nib, I drew tiny feather strokes of masking fluid over the body edges to avoid creating hard lines.

You should not spend time drawing detail into any of the birds at this stage as the masking fluid acts as an eraser when rubbed off the paper.

Second stage I sketched this scene on an early autumn morning with a soft, damp mist and a hint of woodsmoke in the air. To capture this atmosphere I decided to use the wet-into-wet technique over the background, applying several colours – one drifting into the next. When the masking fluid was absolutely dry I used a large, silky brush to dampen the paper all over with clean water. I then mixed a fairly dilute combination of Cobalt Blue and a touch of Burnt Sienna and swept the laden brush across the top of the paper. I worked downwards from left to right, blending one stroke with the next.

After a couple of brush strokes I added a hint of Purple Lake to achieve the misty feel I wanted. Halfway down I began to add more Burnt Sienna and towards the bottom I reversed the proportion of Cobalt Blue to Burnt Sienna, with just a little blue remaining to tone down the fieriness of the brown. All this was done rapidly before any of the paint had dried into hard-edged brush strokes: one colour had to melt softly into the next. With this technique it is particularly important that you think carefully ahead about how you are going to achieve the effect you want before applying brush to paper.

Whilst the wash was still damp I 'drew' short lines very gently with the tip of a scalpel, lightly scratching the paper so that the wet paint sank into these marks to leave dark, very fine, but slightly broken lines. I drew these fairly randomly but concentrated principally on the foreground, drawing fewer towards the top, to suggest wisps of fine grass or straw.

When the paint was completely dry I gently rubbed the masking fluid off with a fingertip, leaving the white shapes of the hens. I could now draw in the individual birds and the detail of their heads. I decided to use masking fluid again to create the texture of the feathers and started by brushing the fluid over the necks and backs. When this was dry I stroked the surface of the masking fluid softly so that it broke into tiny holes and dots which the paint could penetrate. I paid particular attention to breaking up the hard edges where the necks and backs joined the rest of the body. Continuing with this texture I used a pen and nib to draw tiny lines and strokes of masking fluid to indicate the feathers' markings.

Fig. 45 First stage

Fig. 46 Second stage

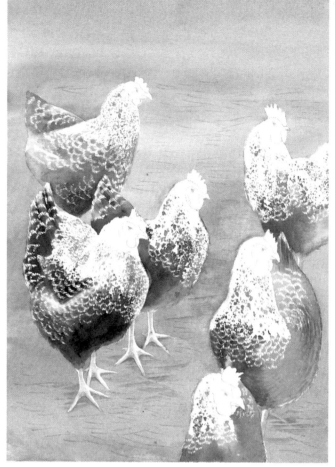

Fig. 47 (*above*) Third stage

Fig. 48 (*below*) Detail from finished stage

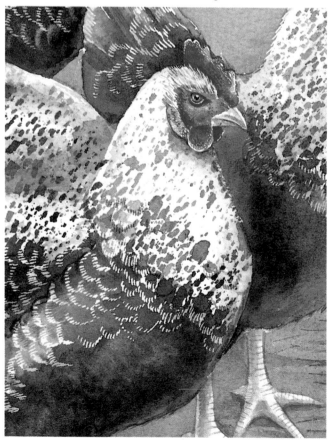

Third stage When the masking fluid drawing was completed I began to apply paint to the hens. With a medium-size (No. 7) brush I laid down washes of Payne's Grey to the bodies. I used darker paint in some areas than in others to model the birds and give them some depth. It is important to remember at this stage that these are not just flat shapes, but plump and fluffy living creatures.

Where one hen overlapped another I made the foreground bird slightly paler and put darker shadows on the ones behind. On the most distant hens I added a little Purple Lake to the Payne's Grey. It is a good idea to use some of the colours included in the first wash in subsequent washes in order to integrate a subject with its background. The subject should blend into the picture rather than stand out like a cut-out shape. With this in mind I used a tiny brush to help break up any hard edges with feathery lines.

I rubbed away the masking fluid when the paint was dry to reveal the patterns underneath. I always find this part exciting. You can never quite tell how it will look until the masking fluid is gone, revealing the results of your earlier labours. You can see the textures that have appeared in greater detail in **fig. 48**.

Next I diluted some of the leftover brown background pigment and painted a light wash over the hens' feet, darkening between the toes and along the sides of the legs to make them look rounded. Then I worked into the background around the feet, adding a little darker colour to plant the legs firmly on the ground.

Finished stage I decided that I should now paint the heads before proceeding any further, as I knew that the bright red colour of the wattles and combs would instantly bring the picture to life and affect decisions about how much more colour to put into the bodies of the hens and the background. I used Cadmium Red for most of the head and toned it with a minute amount of Payne's Grey in the darker areas around the eyes and in the wattles. I described the texture by dotting in tiny marks of darker colour and specks of white gouache. The beak was painted in Raw Sienna and the eyes in Payne's Grey, with Raw Sienna irises.

My main aim at this point was to soften up the harsh whiteness of the rest of the paper and to continue building up the body shapes, which I did by adding a dilute wash of Payne's Grey over the white feather areas. I also added a few details to the legs and put some dark triangular shapes in the background to describe the small areas between bits of straw, using a darker version of the initial colour with extra Purple Lake for warmth. All that then remained was to add a final highlight of white gouache in the centre of the eyes and the painting was complete.

Fig. 49 (*opposite*) Finished stage

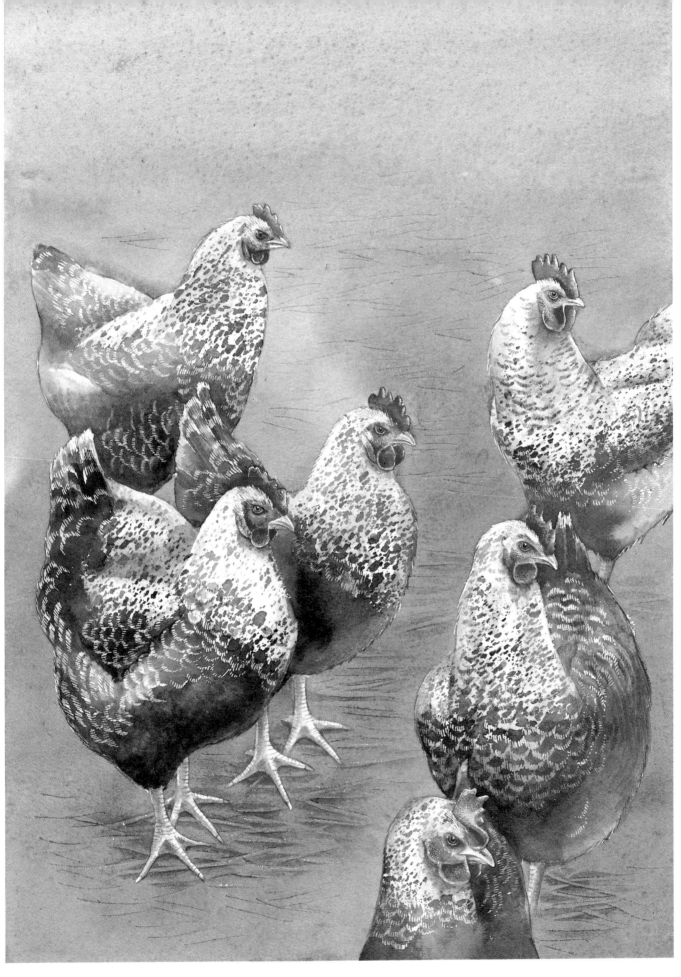

COCKEREL
ASPECTS OF COMPOSITION

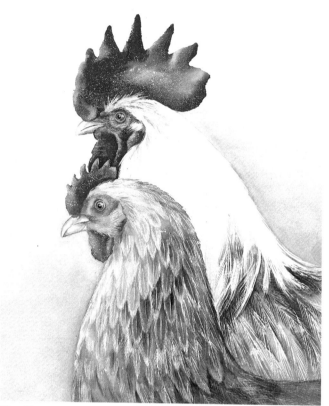

The painting of hens in the previous chapter features lots of overlapping shapes, but I could, of course, have chosen to paint a single hen. It is equally valid to create an interesting design with one element as it is with several, as the painting opposite shows.

To begin with I painted both the hen and the cockerel because one shape acts as a balanced contrast to the other (**fig. 50**). However, as the profile of the cockerel is much more interesting than that of his female counterpart I chose to concentrate on just the male.

Fairly simple subjects like this, set against a plain background, require particularly careful composition. You must look for the most interesting angle to paint, remembering that the negative shape of the background is just as important as the object itself.

The two sketches in **fig. 52** illustrate the importance of composition. The hen on the left is seen straight on, squarely placed in the centre of the page with a blank expanse of paper at the top. The careful symmetry of the poor bird is remarkably boring. The hen on the right, however, is seen from a far more interesting side view, showing the curving neck and beak and a comb that zigzags across the page. In addition, the portrait fills the whole area of the paper. The asymmetry of the shapes around and within the subject creates interest in contrast to the dull symmetry of the first composition.

I painted the cockerel in **fig. 53** much larger than life, giving him a comb a glorious 20 cm (8 in) wide. It is fascinating to enlarge a subject in this way, as it forces you to observe it in such great detail that the image can become quite abstract. Use your eyes and mind as a magnifying glass to discover the patterns and textures hidden from the casual observer.

Fig. 50 (*above*) **Fig. 51** (*below*)

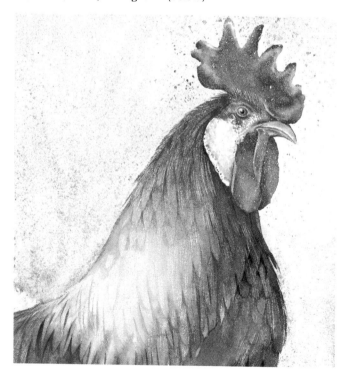

Fig. 52

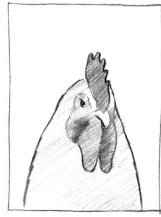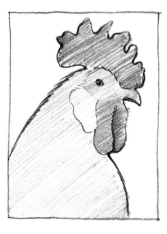

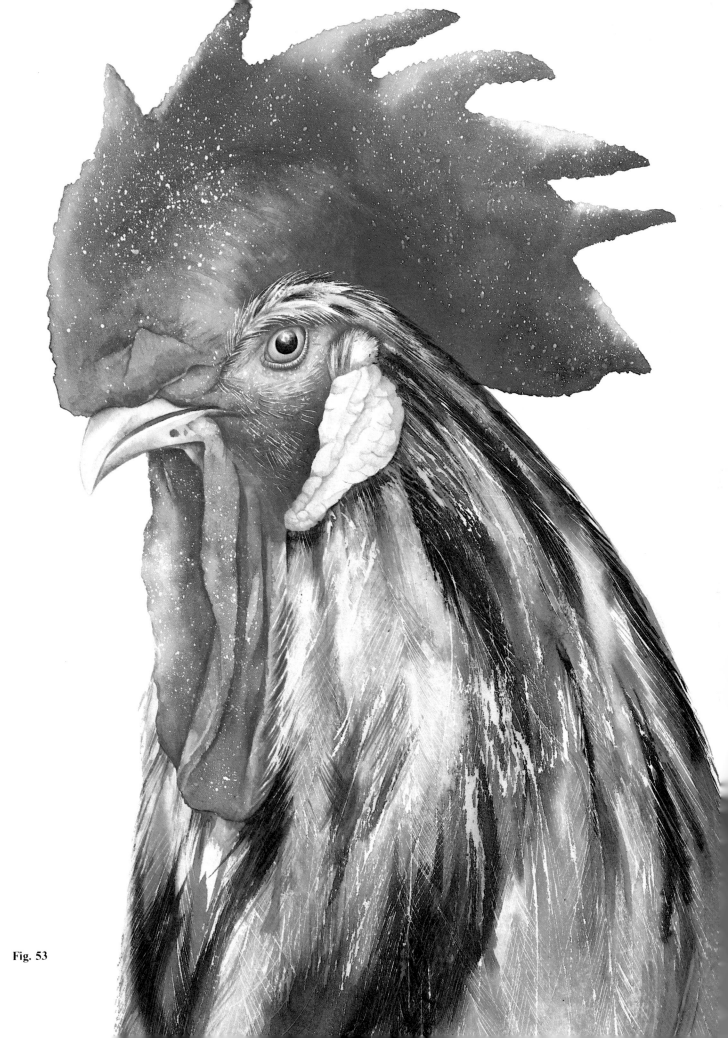

Fig. 53

EXERCISE TWO
COUNTRY WALL

Earlier I discussed the value of sketches and photographs for kindling ideas. This chapter shows you how I have used the combination of a drawing and a snapshot as the basis for a painting.

The pencil study (**fig. 54**) was drawn whilst I was sitting on the grass a scant foot away from the subject, a lovely dry-stone wall. What had been intended as a sketch soon developed into a detailed drawing as, oblivious to the wisecracks from passing hikers, I became lost in the granular texture of the crumbling limestone and the meanderings of ivy stems. Like a miniature landscape, the mountains, valleys and forests of vegetation were inhabited by a multitude of scurrying insects.

I used lots of dots and wriggly, almost scribbly lines to describe the stone, smudging and softening with a finger in some places. I rendered the fibrous quality of the ivy stems with a series of fine lines as they echoed the patterns made by the cracks between the stones.

The drawing was never 'finished' in the formal sense. I reached a point when I felt that I had gathered enough information for future reference and so I carried my wall home on the page of my sketchbook and in my head.

On another occasion, whizzing along a stone-walled lane, late for an appointment as usual, I saw a group of poppies on one side of the road. The petals were fluttering delicately in the strong breeze, accents of orangey red against a sombre background of greys and greens. Not having time for even the briefest sketch and knowing from experience that not recording such a delight immediately was to lose it to the perils of nature for ever, I took the photograph here (**fig. 55**).

Months later, digging through my reference files seeking inspiration, I came across both images and decided to use elements from each for a new painting. When faced with a rainy day and a dearth of inspiration, a 'reference library' of images you have collected is an invaluable aid to stimulating a flow of ideas.

First stage Choosing a soft pencil, I drew with light strokes on a sheet of Bockingford 140 lb paper the jagged outline of the top of the wall. I was careful to keep the spacing and shapes of the stones interestingly irregular with some upright and some slanting. It is important to consider this aspect of composition when drawing a subject composed of a series of repeated shapes. Feel free to emphasize any small differences of

Fig. 54 Pencil study

Fig. 55 Reference photograph

Fig. 56 First stage

size or spacing if it will benefit the design. A line of trees, queue of people or row of stones all of equal size, shape and spacing would usually be visually dull.

I blocked out the sky with masking fluid and without any preliminary pencil work drew in some stalks of cow parsley with a pen and masking fluid, stippling and scribbling in tiny movements the lacy flower heads. I had decided to include these because they relieve the expanse of wall and the upright and diagonal lines of the stalks echo the cracks between the stones . . . and because cow parsley holds a particular fascination for me (see pages 62–4)! I also spattered masking fluid lightly over parts of the wall with a toothbrush, to create the sparkling texture of Cotswold stone.

Second stage First I wet the paper in places, leaving a few spaces. I then mixed three separate washes of colours chosen from the photograph. The first was Warm Sepia and Cobalt Violet; the second was made from the same two colours with a little Black added; and the third was Olive Green with some of the first mixture added to tone it down. I used the first two washes in bands across the top area of the paper and the green wash towards the bottom grassy verge area. The colours flooded together in the areas where the paper was wet and I dragged the brush over the drier patches to leave the white paper sparkling through.

Whilst all this was still wet I mixed a solution of Cadmium Red and lightly touched the brush to the places

Fig. 57 Second stage

where I wanted the poppies to bloom. Bearing in mind the points I made relating to composition, you will note that I related the positions of the flowers to the ups and downs and spacings of the top of the wall. After a while you will find yourself assessing the positioning of the elements of your compositions almost without thinking about it.

Whilst the wall was still damp I crumpled a paper towel and gently blotted up some of the paint, leaving lighter mottles. When the picture was quite dry I rubbed off all the masking fluid (with clean fingers!) and then began to build up the wall, using dark paint in a No. 1 sable brush to draw the interlaid stones. You can see where I have started this process around the centre of **fig. 57**. Shading some of the stones to give them solidity, I drew soft edges where the stone was smooth and curved, and hard, angular edges where it was chiselled and changed direction.

I mentioned briefly on page 28 the importance of linking a tree to a grassy bank. Similarly, when painting any feature, be it a building, plant or in this case a wall, you should always relate it to the ground it stands on. A wall should look as if it has foundations; trees and plants should appear to have roots. You do not want them to look as if they have been placed on top of the ground and are about to topple over. They should grow from their base; you will very rarely see a subject with a hard line differentiating between where it ends and the ground begins.

I find the best way of achieving this integration is to use one wash or several blended washes over the whole area and add definition afterwards, as just described. It also helps if the feature is darker and crisper towards the top, and lightened and softened towards the base, particularly if silhouetted against the sky.

Finished stage At this point I began to define the poppies more clearly. My aim with these was to achieve the feeling of movement captured in the photograph. I wanted to convey the fragile, quivering petals and the delicate swaying stems. To achieve this I felt that an impressionistic approach was required, as for this picture I did not want rigid, immobile and precisely outlined flowers. I find that movement can often be imparted by using a combination of hard and soft edges. Blurred edges only can make an object woolly and indistinct, while hard edges will make it stiff and dominant. The two qualities used together, however, complement each other, the crisper edges attracting attention and making exciting patterns, the softer, gentle edges retiring and blending into the surroundings. This shadowy blurring gives the same impression of movement that you get in a photograph when something moves just as the shutter operates.

Fig. 58 shows you clearly how I progressed through the stages of painting each poppy. **Fig. 58a** shows the washes of different wet colours merging into each other with a drip of red paint spotted in (as in **fig. 57**). It is quite difficult to predict just how such a combination will react and spread, for it depends on exactly how wet the paper is, how liquid the drop of paint and how much of it there is on the brush. This is not really important, however; what you are trying to achieve is a soft foundation from which to proceed with further crisp brushwork.

Fig. 58b illustrates the way the poppies are built up with stronger red paint, letting some petals drift into the background and bringing others forward with hard edges. Use darker paint in the shadows. To create the crepe paper effect of the petals I use the side of a fairly dry brush and work from the inside of the flower out to the edges (as shown by the arrows). The stem is drawn with a fine brush, starting at the top and dragging downwards.

The next stage (**fig. 58c**) is to continue deepening the shadows, especially around the centre. Add more creases to the petals if necessary and modify any edges that become too hard by moistening them with a damp brush. Darken the background in places behind each poppy to bring it forward. Finally, dab in the dark sta-

Fig. 58 The stages of painting each poppy

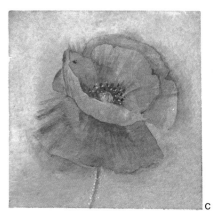

a

b

c

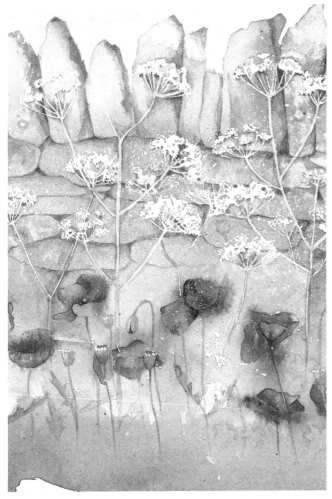

mens with a small brush and flick out a few fine white hairs on the stems, using the tip of a scalpel to break the surface of the paint so that the paper shows through.

The result now looks impressionistic and fragile, reflecting the nature of these delicate flowers, with the first washes showing through subsequent layers of paint to give the transparent effect of sunlight shining through the petals. **Fig. 59** shows clearly how the poppies integrate with the rest of the painting.

Now that the poppies were completed a little more work on the wall was required. Throughout this process I referred to my drawings for information about the characteristics of the stone. I included a little of the ivy recorded in the pencil study, shading around the leaf shapes with paint and tinting them with the pale olive colour. I treated the ivy quite subtly as I wanted it to blend in with the stones, almost as if it was part of the very fabric of the wall and not a separate feature.

I then accentuated the cow parsley with a little darker tone and softened the white stalks with a light green. Finally, I painted the sky very simply with a flat wash of diluted Raw Sienna, being careful not to wet the top of the wall and risk smudging it.

Fig. 59 (*above*) Detail from finished stage

Fig. 60 (*below*) Finished stage

EXERCISE THREE
FARMYARD PUMP

A different sort of wall is featured here from the one in the previous chapter. It is the crumbling wall of a derelict stone barn. This would be an interesting subject in its own right, but its function in this painting is to act as an out-of-focus backcloth to the focal point, an ancient pump.

One of my current obsessions is old water pumps. Before this interest developed I would have assumed that there were maybe one or two such features locally. Now that I am on the lookout for them they seem to be appearing like mushrooms in every village and farmyard I pass. I now feel obliged to stop and draw them all, convenient or not (see **fig. 2**)!

The pump I chose to paint here is a rusty, neglected farmyard contraption, which stands in a tangle of grass and weeds sprinkled with a few dancing cornflowers. I like its odd shape with the long elegant curve of the handle at right-angles to the stumpy spout. A crusty surface has built up from years of rust and layers of different coloured paint. Most of these layers have been worn away by sun, rain and decades of use to leave only a few clinging flakes and fragments of pigment. I decided to paint my version of the pump in quite a lot of detail to build up a similar texture to the original. Whereas in the previous chapter I portrayed the texture of the wall with a shower of dots and flecks of white, here I wanted to play down the wall's surface detail to create the maximum contrast to the pump. I merely hint at the colours and shapes of the stone.

In **fig. 65** you will see that I decided to include some foreground detail in my painting. For the purposes of this exercise, however, you should try to concentrate on portraying the different textures in the wall and the pump. So that you can see the painting closely at its different stages of development I have taken a section from the top half which clearly shows the important aspects of this picture: the softly hinted background and the darker centrepiece, painted in much more detail.

First stage In order to achieve the rough, textured finish that I wanted I selected a sheet of Whatman 140 lb Rough from my paper collection. I used a 2B pencil to draw the outline of the pump lightly, making sure that I did not exert sufficient pressure to dent the soft paper. I was careful to fill the rectangle with the shape of the pump to make a pleasing composition, as I did when drawing the cockerel on page 34, and I then blocked out this shape with masking fluid.

Second stage I mixed some watery washes of paint, using combinations of Burnt Sienna, Hooker's Green and Monestial Blue, and blended these over the background with a No. 12 brush. While the painting was damp I took a clean, moist No. 8 brush and lifted paint out of the wash with horizontal and vertical brush strokes to indicate the pale mortar. When this was dry I rubbed off the masking fluid, being particularly careful not to spoil the very soft paper's surface.

I then drew in some guidelines of the details on the pump. A cylindrical object like this demands accurate drawing and a basic knowledge of perspective. A cylinder is constructed from a series of ellipses. At eye level or the horizon, the ellipse appears to be a straight line. As the ellipse rises above or drops below eye level it gets progressively deeper. To demonstrate this, I suggest you take a cylindrical glass and hold it in front of you level with your eyes so that the rim of the glass forms a straight line. You will notice that the bottom, being below eye level, forms an ellipse. Move the glass slowly up and down to see how the ellipses of top and bottom change in depth as they move towards or away from your eye level.

I applied this theory when drawing the main body of the pump. My eye level was at the point where the handle begins to curve outwards, so the ellipse here was drawn as a straight line. All the other points on the iron tube, like the rim of the lid and the bulbous joints which were above or below eye level, were visualized as ellipses. Of course, as the pump is an opaque object I drew in only the curves of the front, visible part.

Third stage I studied the tones and colours of the pump carefully. The light came from the left and above, leaving the right side of the tube and the underside of the spout, handle and lid in shadow. Ignoring the incidental flecks and spots of pigment, I analysed the basic patterns of colour, which were grey-blue, soft olive green and a browny tone that echoed the colour of the wall. Having saved some of the first washes, I now split them into three, modifying them with Burnt Umber, Monestial Blue or Hooker's Green to match the three different colours I had identified in the pump.

I painted these pale mixes on to the pump with a No. 8 brush in small washes to establish the different areas of tone and colour and to define shapes and decorative details. Notice how a texture has already begun to develop purely due to the rough surface of the paper resisting the paint in places to leave speckles of white.

Fig. 61 First stage

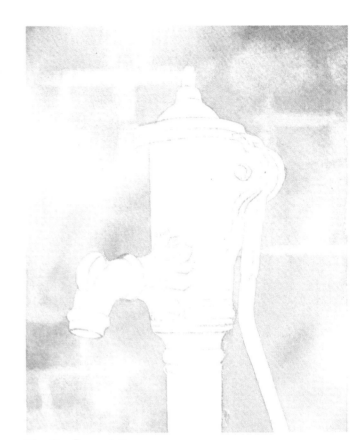

Fig. 62 Second stage

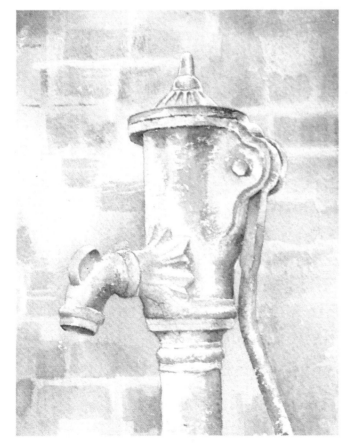

Fig. 63 Third stage

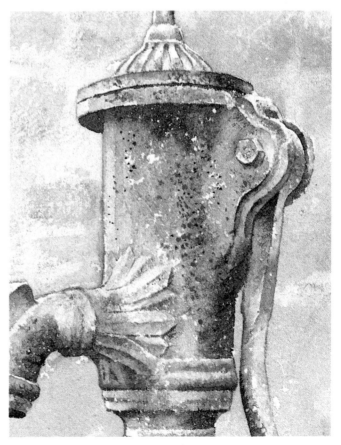

Fig. 64 Detail from finished stage

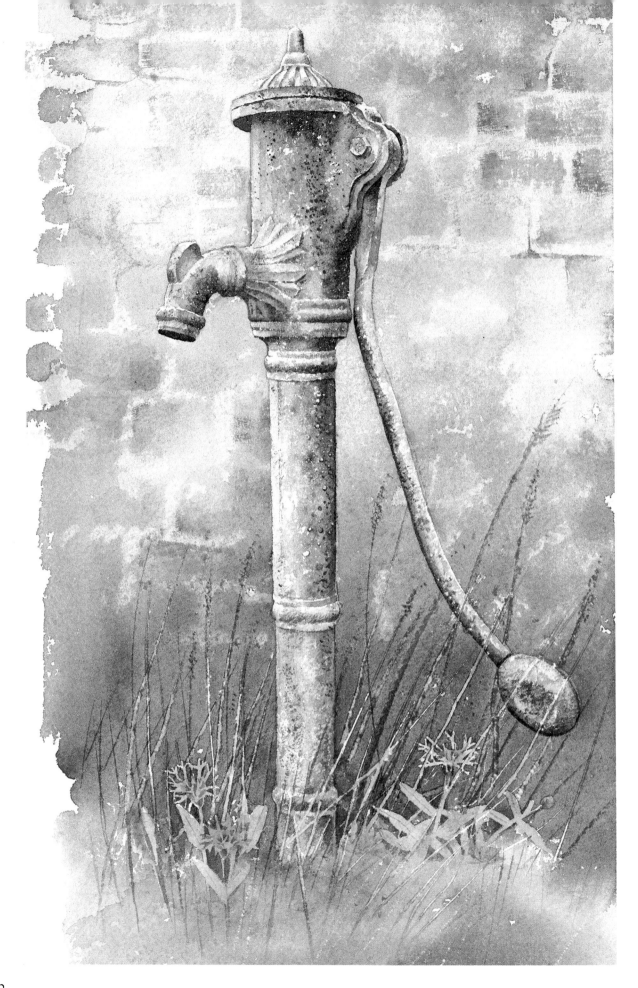

The wall needed a little more definition, so I picked up a small amount of the first wash with the top edge of a flat brush. I dragged the paint sideways in soft-edged, block-shaped brush marks, following the shapes I had suggested in the first stage.

Finished stage I continued to strengthen the colour and tones of the pump, making any shadowy parts much darker. I intended the picture to be subdued but it was looking a little drab at this point. To liven it up I diluted some Monestial Blue with clean water and dabbed this on to the spout and body of the pump. To indicate the flaking paint I picked up concentrated pigment straight from the tube with a No. 00 sable brush and stippled spots of colour all over the pump, first Alizarin Crimson, followed by Monestial Blue. Finally, I flicked out a few white dots with the point of a scalpel, to represent the light glistening on the encrusted surface. You can see the finished texture clearly in **fig. 64**.

PAINTING OTHER COUNTRY WALLS

The wall in the painting on page 39 was a Cotswold dry-stone wall made from the Oolitic limestone that seems to sparkle with texture and change colour from purply grey on a winter's day to mellow yellow under a warm sun. The old barn wall behind the pump illustrated on the left was built with stone similar to that in the walls of my former cottage and studio in Oxfordshire – dark umber and sienna ironstone, veined with purple metal-rich ore. This was quarried not far away by the men for whose families the cottages were originally constructed.

Walls, of course, are built from many other different types of stone: coarse-grained, crystal-speckled granite; the dour blue-grey carboniferous limestone of the Pennines; rounded flints, sometimes split to show the smooth, shiny surface inside; pale pebbles; blue slate, and so forth. Some walls use a combination of materials such as chalk, flint and brick.

You may like to experiment with ways of describing the stone or other building material characteristic of your locality, choosing from or combining the techniques illustrated at the beginning of the book.

To achieve a similar look to that in **fig. 66**, choose a rough-textured paper. Paint a pale wash of Burnt Sienna over a small area, not worrying about getting it too flat. Let the brush drag over the paper sometimes leaving specks of white. Rub over this when it is dry with the stump of a white wax candle; do not use a coloured candle or you could end up with some very strange results. On second thoughts, it may be quite an interesting experiment . . . I might try it!

Mix washes of different colours: I used combinations of Burnt Umber, Burnt Sienna and French Ultramarine. Paint in the shapes of the stones, studying the way in which your kind of wall is constructed, but using your discretion to keep the composition interesting. You will now be able to see how the wax has caught the paper unevenly, sticking to the 'bumps' but leaving the 'dips' untouched. Where the wax has stuck it resists the paint, resulting in this rough, crumbly texture.

Fig. 66

Fig. 65 *(left)* Finished stage

EXERCISE FOUR
FROG

I can understand why some people have an aversion to certain reptiles and amphibians, but the frog is too endearing a character to be categorized as a 'nasty', fit only for the witch's cauldron. From a painter's point of view they are fascinating to portray because the many types of toad and frog have such wonderfully patterned and textured skins.

To paint the frog in this exercise I chose a particular combination of techniques because they seemed an appropriate way of describing the patterned skin. However, there are any number of ways in which this could be conveyed. On another occasion I may well have treated the same subject in a completely different manner. There are no rules to say that you must paint a subject in one particular way.

In **fig. 68** I have painted some simple frog shapes to demonstrate a few of the other techniques I could have used. Some are quite restrained granular textures, others are more blotchy and dramatic, perhaps more suitable for a warty toad than the relatively smooth-skinned frog. In these demonstrations I have dropped ink into watercolour, used masking fluid applied in different ways, blotted pigment out and printed it in, or used combinations of these methods. You will be able to work out which is which by experimenting with these techniques for yourself. Refer to the 'Experimental Processes' chapter for a reminder, or invent your own.

I liked the idea of painting a frog sitting on the leaf of a water lily on the surface of a still, murky pond. I wanted to keep the painting simple, in a limited colour scheme, with the flat, overlapping ovals of lily pads contrasting the main area of interest, texture and detail in the frog.

First stage I began by drawing the outline of the frog with an HB pencil on a sheet of Whatman 140 lb Not. I positioned him at an angle that emphasized his triangular shape – a wide rear created by two large hind legs, tapering up to a small head. I filled the shape in with masking fluid and let it dry. Bearing in mind the sombre atmosphere I wanted to evoke, I mixed my colours. I diluted some Monestial Blue for my first wash, some watery Burnt Umber and Monestial Blue for the second wash, and some Hooker's Green No. 2 toned down with a little of the blue and umber mix for the third wash.

I dampened the paper with clean water so that the colours would flow together easily, then, beginning at the top, I brushed in the blue wash to give a hint of sky

reflecting in the pool. I quickly changed to the Burnt Umber and Monestial Blue mixture, brushing it further down the paper, and continued with the green wash, letting the colours merge into each other. I used slightly darker paint at the bottom than at the top so as to bring the foreground forward. You will find that this is a useful way of creating depth in a picture: pale colours usually recede behind dark ones. In a similar way, warm colours tend to attract attention and therefore advance in front of cool ones. My reason for putting the cool blue at the top and the warm brown at the bottom, therefore, was not purely to represent reflected blue sky and muddy pool, but to create depth in the picture.

Whilst all these washes were still damp I roughly blotted out the shapes of some water lilies, using the corner of a paper towel, and lifted a few ripples out of the foreground with a clean, moistened brush.

Fig. 67 First stage

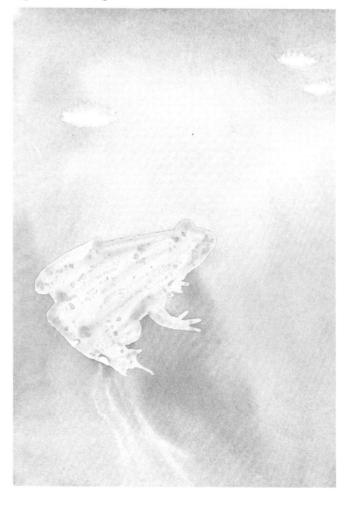

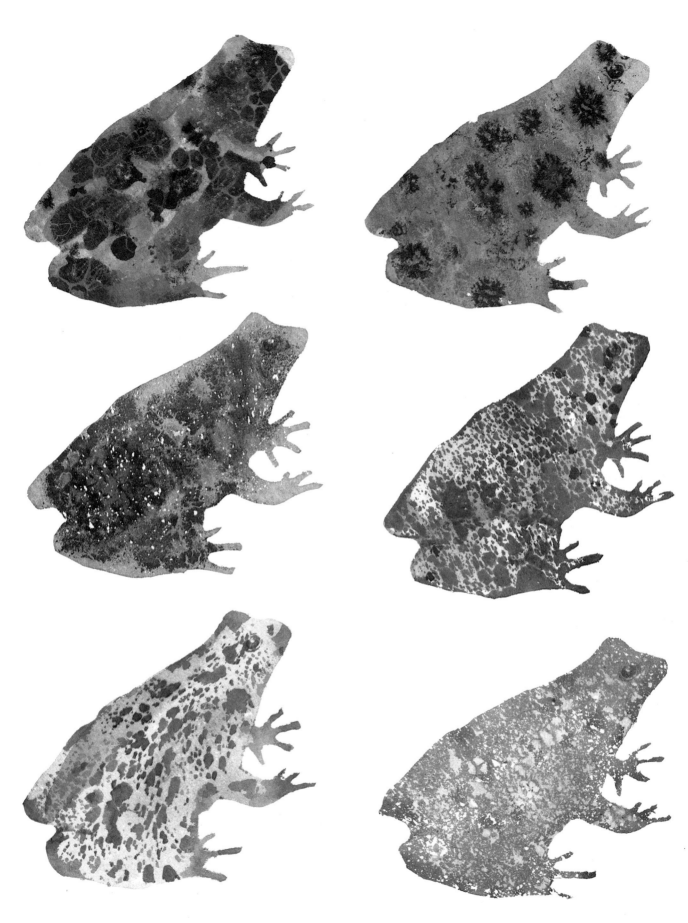

Fig. 68

Second stage Leaving the masking-fluid-covered frog untouched at first, I began to draw the surrounding lily leaves lightly. Although water lily pads are more or less circular when drawn in plan, the appearance of them, and any other circular object, depends on the eye level, as already mentioned in the previous chapter. As the eye level in this picture is quite high – in other words, we are looking down on to the frog – the ellipses at the top are narrower than those at the bottom. Perspective also means that objects appear to diminish as they retire into the distance. Therefore, the lily leaves at the top are smaller and narrower than those at the bottom.

I used stronger solutions of paint than before to build up these oval shapes. I defined them by sometimes darkening the underside edges to give shadows and at other times darkening the top edges so that they contrasted with the pale areas and made patterns of light and dark. The strongest colour of all was used under the leaves at the bottom to create shadow and beneath the frog to help him sit firmly.

I crispened up the vague water lily shapes by adding darker paint around the edges and roughly indicated the reflections underneath them by painting blue pigment around each jagged shape so that the reflection

Fig. 69 Second stage **Fig. 70** (opposite) Finished stage

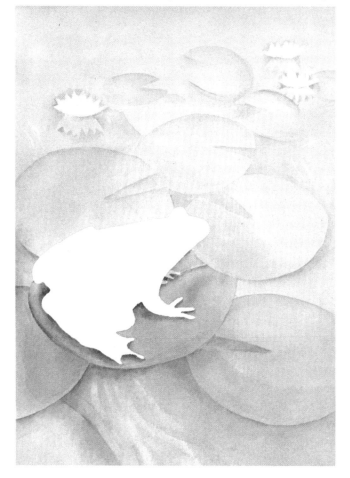

itself was made from the initial pale wash. Then I rubbed off the masking fluid from the frog.

Finished stage I painted in the front petals of the water lilies with pale blue and brushed a soft-edged smudge of Cadmium Yellow into the centres. Notice that the reflections are not just the reverse of the lily. Many mistakes are made by thinking that a reflection is simply a tracing of the object turned upside down. Remember that you are looking slightly down on the lily but are looking up in the mirror image. For example, you can see inside the lily to the yellow centre, but in the reflection you can see only the underneath and side of the petals.

When water is smooth and stagnant as it is here, the reflected image will be as complete and solid a shape as the object itself. As the surface of the water is disturbed and broken the mirror-like reflection is distorted. When the water is completely broken into numerous small ripples, the reflection is totally lost other than in a diffused area under the object.

Having painted these reflections at the top where a little light was falling, I decided not to paint any more at the bottom. I darkened the shadows a little in this area instead as I wanted to keep to my original concept of an almost opaque swamp-like environment.

I now began work on the frog. I blocked out the large eye with more masking fluid and also spattered some over the body of the frog with a toothbrush, shielding the rest of the painting with scrap paper.

I mixed up a strong blend of Hooker's Green with Burnt Umber and some Raw Sienna, then painted over the frog with both colours. I alternated dark and light areas and edges, as before, to define the back, legs and mouth, constantly assessing the parts to shade to give roundness to the body and limbs. Whilst the washes were still wet I dropped small amounts of Indian ink into them so that they coagulated into irregular granular circles and patches. I rubbed the masking fluid away when this was dry and drew round some of the resulting white dots with a No. 00 brush to emphasize them. Other dots were washed over with pale solutions of colour to tone them down. The eye was painted with Cadmium Yellow and the pupil with black Indian ink, leaving a white circle as a highlight to give him his beady-eyed appearance. Using the point of the small brush, I dotted in some texture and tone around the eyeball to add definition and create the bulging effect.

Finally, I went over the whole painting to reassess all the tonal values and to ensure that the frog was completely integrated with the background. If you use this sequence of processes, which leaves one part completely untouched until the final stage, it is important to check the overall balance between subject and background. There is nothing worse than an object that looks totally divorced from its surroundings.

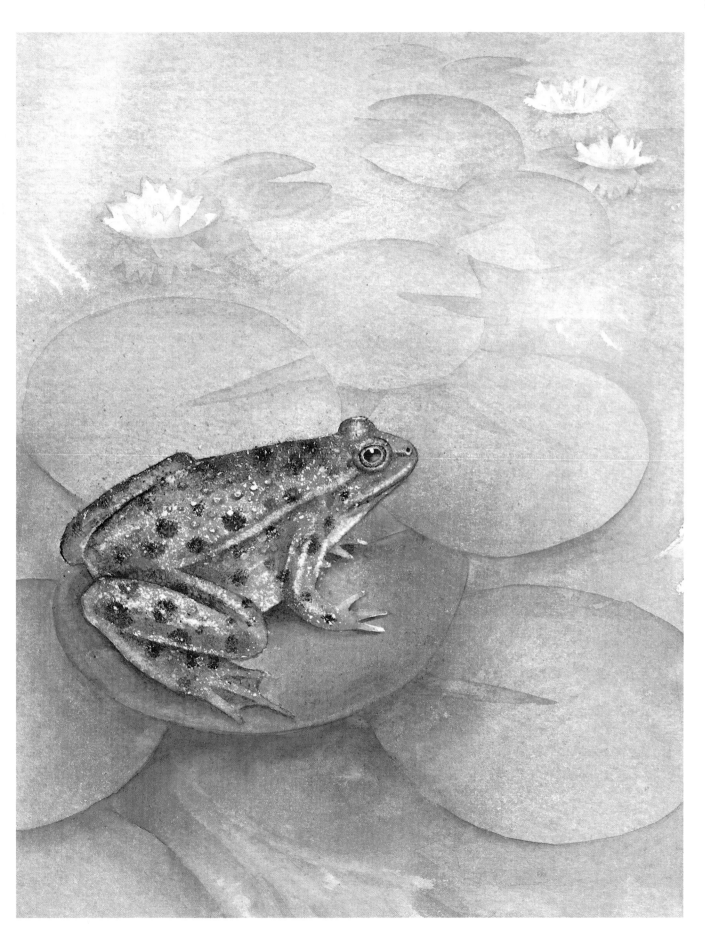

CATTLE
OBSERVING ANIMALS

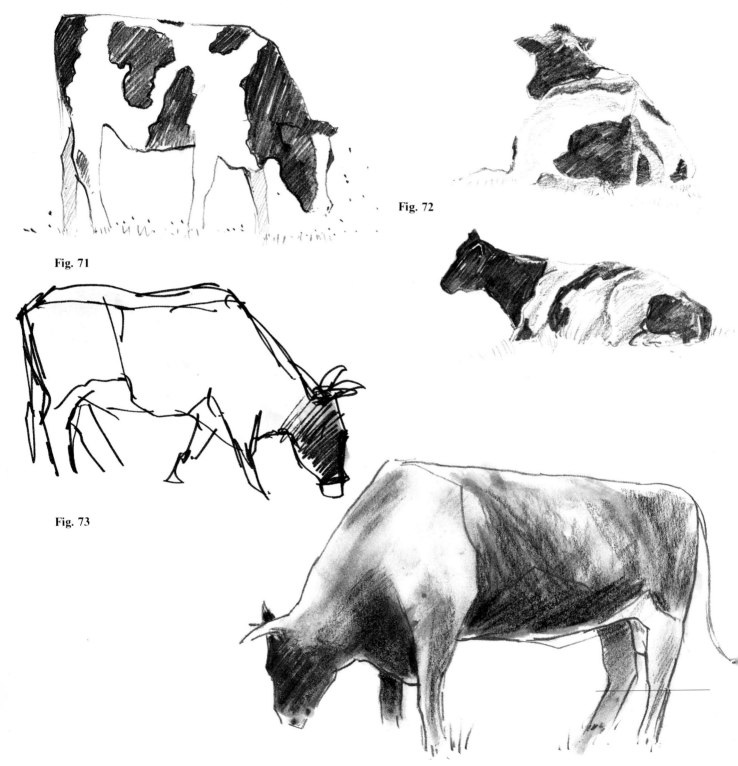

Fig. 71

Fig. 72

Fig. 73

Fig. 74

A meadow full of grazing cows is a sight familiar to most of us. Cows are among my favourite farm animals to paint and draw and fortunately for the artist they are particularly obliging models. They will sit or stand for long periods quite immobile, except for their slow, eternal chewing, whilst you paint or sketch. Even when they graze they move slowly with their lovely, ponderous, swaying gait. My cottage is surrounded by fields of cattle, usually Friesians and Charolais, but occasionally the less common breeds from the Continent or the Channel Islands to give a variety of subjects for my sketches.

For you to draw and therefore paint an animal well it is necessary that you understand its behaviour, personality and something of its physiology in order to capture the essence of the subject in your work. Sketches such as the ones shown here are made as aids to observation and can be used to document your growing understanding of your subjects as you persevere with your drawing.

Pattern and form

My favourite breed of cattle is the Friesian with its wonderful black and white ink-blot patterns as illustrated in my pencil drawings (**figs. 71** and **72**). The grazing cow was drawn with a soft 6B pencil; note the different blocks that form the pattern on its hide. The sitting cows are a little more complicated. Whilst the markings on the animals are still important to the composition, I have used shading to describe the loose and curvaceous bulk of these beasts as they collapse into fleshy mounds.

I suggest that your early sketches of animals be drawn from a subject that is in repose. This will allow you more time to observe the animal's form and to learn how it is put together. It is also rather easier to control your pencil strokes when comfortably seated than when sprinting around the field after a reluctant heifer!

Outline

Felt-tip pen is a good medium for making a rapid sketch of an outline. The permanency of this medium offers an extra incentive to concentrate somewhat harder than usual as one cannot remove an ill-made mark with a touch of the eraser.

When I drew the bull in **fig. 73** I was concentrating simply on the directions of the lines and the relationship of one line to another. The tonal value and mass of the beast did not concern me for this study. I was exploring his angular qualities: the diagonal, downward thrust of his head against the horizontal flat line of his back; the zigzagging of the hind leg in contrast to his vertical tail.

Bulk

I drew this huge and somewhat tetchy bull (**fig. 74**) from the safe side of a very sturdy fence. You may wish to suffer for your art . . . Me? I was taking no chances! His great bulk and bad temper seemed best described by using lots of strong tone and angry scribbles. I chose a black conté pencil, charcoal and crayon to draw with. The palest area shows the strength of the broad and massive shoulders which taper along the length of his back to a dark, narrow rump. The roundness of his belly is emphasized by darkening the animal's underside.

Movement

When drawing a moving animal you have to work quickly to register a pose, but it is still vital to spend time observing what is in front of you. You should always spend more time looking at your subject than at your paper. There is little point in scribbling frantically in your sketchbook, taking only brief glances at your model, in an attempt to keep up with its movements.

The watercolour sketch in **fig. 75** was drawn quite rapidly, even urgently, to note down each position as it occurred, but I was always conscious of the need to avoid carelessness. This drawing is obviously not an anatomical study, but my aim was to capture something of the character and personality of the cow as well as the feeling of movement. It shows the animal alert, almost tense, looking straight at me as I approached.

There are elements of design even in a quick sketch like this. The hindquarters are crisp and angular. The body is solid black, but brushed on quickly so that the edges are blurred in contrast to its rump. A strip of light breaks across the body, lending important relief to the mass of black. The action of the dry brush again suggests movement in the legs.

Fig. 75

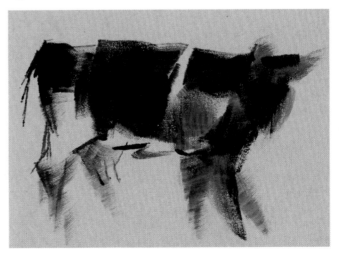

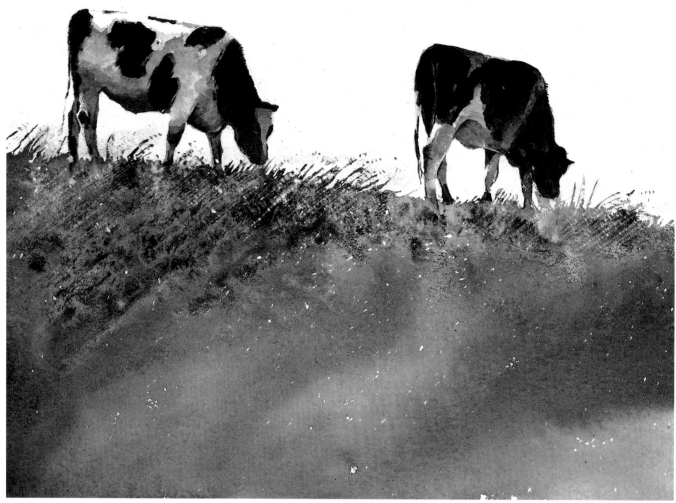

Fig. 76

Although it is constructive and enjoyable simply to sketch animals, at some stage you will probably wish to progress to painting them. You will now need to embody what you have learnt from your observations of the animal's form whilst sketching, and to consider the composition and atmosphere of the picture as a whole.

My two paintings in **figs. 76** and **77** both have similar subjects: side views of a small group of cows grazing in a field. Although the pictures are identical in shape and size, they are quite different, a series of different decisions and choices having been made in each.

Using different eye levels

The main difference between the two pictures is in the choice of eye level that I have made. **Fig. 76** shows the cows on a high grassy bank. I was sitting at the bottom looking up at them. Viewed in this way they were silhouetted very boldly against the sky, making

a statement that dominates the painting. In contrast, I have composed the painting in **fig. 77** as if I was now standing on the bank looking down at the cows in the meadow. This has the effect of softening the composition.

To summarize: when painting out of doors, a low eye level emphasizes the composition and tends to throw the subject into relief against the sky, making the effect bold. A high eye level is less dramatic and is further softened by avoiding contrast against the sky.

Diagonals

Neither of these two paintings relies on eye level alone for its interest, however. In **fig. 76** I have used diagonal brush strokes of Hooker's Green and Burnt Sienna to give an effect that softens the boldness of the silhouetted subjects. This is a simple wet-into-wet wash. The edge of the wash slopes gently in the direction of the cows' movement and the fringe of grass that edges this

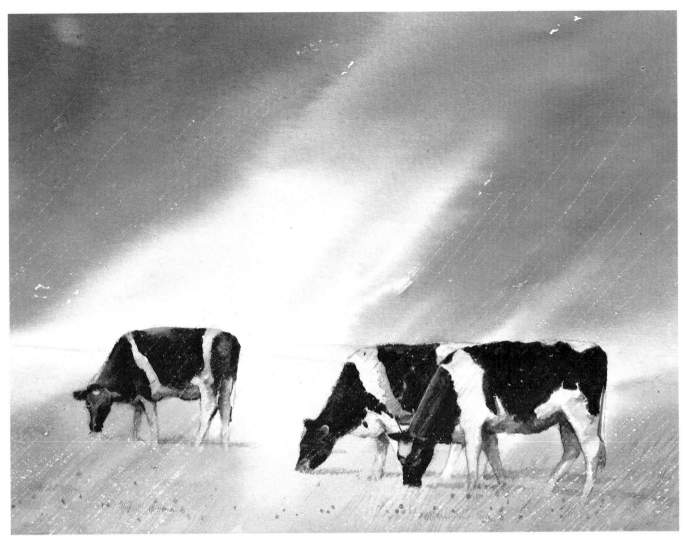

Fig. 77

area also leans forward. Although subtle, all these minor points create movement in the painting which would otherwise be missing.

Fig. 77 would have been a very serene painting if eye level had been the sole governing factor in the design, but by bringing other elements into play I have counteracted this. For instance, I have slashed angry diagonal brush strokes across the paper to give the scene a stormy sky which breaks in the middle, throwing a shaft of light and rain slanting over the grazing cows. Again the wet-into-wet technique portrays this effectively.

The atmosphere you evoke in a painting can be greatly influenced by the direction of lines and shapes within the design. Straight, horizontal lines – in an un-interrupted flat landscape, for instance – will seem quiet and tranquil. As soon as any sort of vertical mark is made – a person, tree or telegraph pole – the eye will immediately be attracted to it. The strength of this attraction diminishes as the number of verticals grows.

Conversely, if you want to bring a feeling of excitement or movement into your painting, a few well-placed diagonal elements will help you to achieve this, as I have done with the two pictures here.

Skies

Perhaps the most obvious way of creating different atmospheres for your paintings is by your choice of light, tone and colour. This applies particularly to the way you treat the sky, as this can set the mood of the whole picture.

In **fig. 76** the sky has been tinted with a very pale wash of Burnt Sienna, just toning down the white of the paper. This plain, uncomplicated sky gives full contrast to the dark cows and sombre, subtle colours of the foreground.

In **fig. 77** the dramatic shaft of light piercing the dark clouds illuminates the grass to a vivid lime-green col-our. This is the sort of sky from which rainbows spring.

51

THISTLES
ABSTRACT PATTERNS

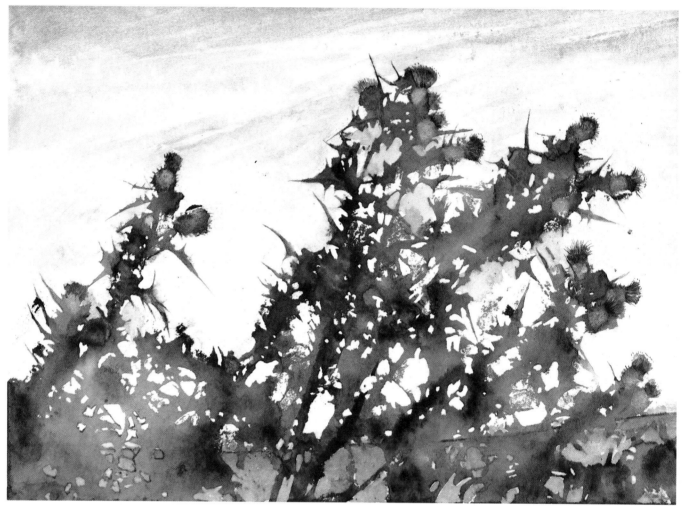

Fig. 78

This large clump of thistles reminded me of the poem by Ted Hughes in which 'Thistles spike the summer air . . . a grasped fistful of splintered weapons'. Their visual impact was tremendous, with dark spikes and bristling heads thrusting upwards, silhouetted against the sky, light dazzling through the gaps.

Looking for abstract patterns and negative shapes

I saw the painting in **fig. 78** as an abstract pattern, in which the negative shapes of the brilliant sky were just as important as the positive ones made by the plants. Squint at the picture through half-closed eyes to eliminate the colour and detail and you will see what I mean. Turning a painting upside down can also help you to

see its abstract rather than simply figurative qualities. I wanted this painting to have the feel of a wood-cut whose negative spaces have been chipped away to reveal the picture.

Profiles

I decided that the thistles would look most dramatic viewed from below, looking up through them to the sky. I drew in the shape of the skyline with a soft pencil, being careful to draw the profile of the thistle heads accurately. Profiles can be very descriptive and will explain a shape with economy, just as a person is instantly recognizable from a silhouetted profile of head and shoulders.

Fig. 79 Ink silhouette

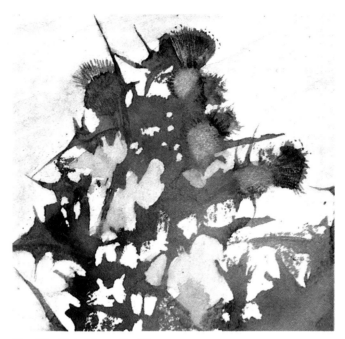

Fig. 80 Detail from **fig. 78**

If the profile is accurate, the rest of the picture can be much looser and more imaginative in treatment. When you have a complicated subject you must be selective in determining that profile, concentrating on those over-all shapes which you consider to be most important to the design and character of the subject. Only when these have been established should you begin to elaborate on incidental detail.

I arranged my pattern of thistles so that there were several strong diagonals through the cluttered growth, suggesting the main stems. Remember that diagonals add the most drama and movement to a silhouette, as discussed in the previous chapter. When I was happy with the main framework of diagonals I began to fill in the negative shapes with masking fluid, using a small brush and a pen nib to get into the intricate corners. I elaborated on some of the shapes as I wanted them to look like holes torn through stretched fabric held together by thin threads, thus adding to the feeling of tension within the composition.

I mixed strong washes of dramatic colours – combinations of Purple Lake, Crimson Alizarin, Monestial Green, Burnt Sienna and Payne's Grey. Some I mixed together and some I left pure. The masking fluid allowed me the freedom to use sweeping brush strokes over the thistles, encouraging the colours to mix together on the paper and create harmonies that I might not have thought of myself.

When the washes were dry I rubbed away the mask. The tiny specks and flecks of paint which I had deliberately allowed to seep through 'faults' in the masking fluid had enhanced the wood-cut effect, as if the block had been imperfectly chiselled away in these spots.

Look how the white gaps 'sing' through the forest of dark thistles. This is because the gaps are small and are surrounded by hard-edged dark washes.

Pinpoints of light really dazzle through a dark hedge, whilst dark berries against an expanse of bright sky will seem much blacker than larger areas of a bough of similar tone. This knowledge will enable you to make decisions about the tonal values of different components within your painting, allowing you to emphasize or subdue them as you wish.

Final touches

Returning to my painting, I then had to make my pattern into something recognizable and to do this I added the merest hint of definition. With the corner of a damp sponge I blotted out soft circles at the top of the thistles to represent the flowers and painted in the plumes with closely drawn fine lines of dark purple, using a No. 00 brush.

Look at the ink silhouette (**fig. 79**) and the enlarged detail (**fig. 80**). The former is obviously just a shape. The latter is also a shape, but has been transformed into a group of thistles just by using a little detail and a few evocative colours. By keeping detail to a minimum you can achieve the fluid continuity that is one of the true joys of watercolour.

Finally, I painted in the sky, using a neutral purple-grey left on my palette. I made short diagonal strokes with a No. 10 brush, echoing the direction of the thistles. Using a cool pale grey, I then painted a narrow strip along the bottom of the picture to suggest the field behind the plants.

NATURE DIARY

As I walk in the woods and pastures throughout the four seasons, my eye is often caught by clusters of berries, sprays of blossom and many other lovely natural details that make up the countryside. I enjoy studying these details and feel that they make worthy subjects for paintings in their own right. Over the past years I have made many of these little studies and have collected them together into a nature diary recording the walks I have enjoyed so much.

Although such detailed studies are much more finished than sketches they can serve the same function – as permanent visual reminders of the things you have seen. They can also be a useful source of reference for a complete painting in which a slapdash detail could spoil an otherwise well-drawn picture. For example, the insight you would gain by painting twigs like those here would build knowledge and confidence for a subsequent tree painting.

Spring

The aspect of spring I love most is seeing the bare lattice of winter branches developing buds and slowly unfurling tender young leaves, dusty catkins and the frothy lace of blossom.

Fig. 81 shows examples of some typical spring sights: horse chestnut branches with their sticky mahogany buds; delicate blackthorn blossom; and strings of catkins swinging in a breeze. All of these were painted using the same traditional watercolour techniques that were applied to create pictures in the rest of the book.

The twigs were built up by laying a flat wash of pale colour, then gradually building up tone with further washes, darkening the areas where the contours of the subject turn away from the light. It is easy to forget that something like a twig silhouetted against the sky is a rounded tube and not a flat shape. The 'edge' of the shape is not an edge at all and the twig has a dimension other than the outline it makes against the light and on your paper.

You can describe this shape by building up layers of washes as I have done or by painting a graded wash. This will be on a very small scale, of course, but the principles are the same as for larger areas, using dark paint on the shaded 'sides' of the twigs and diluting it gradually to become palest on the areas of highlight.

The twigs were painted mainly in browns and greys, but for the fresh young leaves of the horse chestnut I used a pale green mixed with Lemon Yellow.

Fig. 81 Blackthorn blossom, catkins and horse chestnut buds

I painted the blossom with very pale washes of colour to keep them as transparent and light as possible. The broken outlines around the white petals were necessary to define them against the white background and were painted with a No. 00 brush to keep them as fine as possible. Try not to define things with harsh lines all the way round as this looks so awful – nothing in real life has a line around it!

The dots on the stamens were painted with dabs of the brush point. I used the same small brush to paint the crumbly-looking catkins. First I washed a colour over the general shape and then I drew lots of small circles and dots with brown paint to describe the texture.

Summer

In summer the countryside becomes a glorious tapestry of wild flowers: foxgloves, meadow cranesbill, honeysuckle, campion, clover . . . the meadows and hedgerows are richly decorated with them all. The colours of summer flowers are either deep and vibrant or pretty and pastel, with hot pinks, mauves, blues and yellows predominating. You will probably need to extend your range of paint colours to represent all these gorgeous hues adequately. If you have not already done so, I suggest you buy Cadmium Yellow, Permanent Rose, Cobalt Violet, French Ultramarine and Purple Lake. With these additions to your basic palette you should be able to mix colours that closely match most flowers.

Transparent petals with sunlight shining through them need to be painted with delicacy and sensitivity. By using thin washes of paint to build up the colour gradually you will avoid opaque, solid-looking flowers. It is very easy to overwork flower paintings. I always have a tea break just before I think a flower is finished so that I can come back and review it with a fresh eye. More often than not I then decide to leave it as it is. The meadow cranesbill in **fig. 82** is an example of such a flower study. I could have taken this a stage further to strengthen the colour of the violet blue, but I decided that this would spoil the transparency of the petals. In retrospect I still feel that this was the right decision.

Before you plunge into drawing out your flower or any other nature study it is a good idea to view it thoroughly from every angle first. It is often assumed that a subject looks best from the front, but some are more interesting as a profile or three-quarter view than faced square on – myself included!

Fig. 83 shows two studies of the same stem of foxgloves drawn from different angles. They are equally effective in their own right. In the profile I liked the way that all the bells are twisted round, facing in the same direction to reach the sunlight. They make an interesting repeated pattern echoed by the row of small leaves sticking out from the other side of the stem. In the other study the bells are all facing the front and it is the pattern of white and purple spots that is now the important feature. This figure also shows how I progress with a painting. The first stage of pencil outline can be seen at the bottom, preliminary washes of colour further up, and the finished work at the top.

When painting flowers I am always aware of a sense of urgency brought on by the fact that the subject will be changing visibly all the time I am studying it. You have to achieve a balance between being careless and being so painstaking that the plant dies or all the petals drop off before you have finished. Several of the foxglove bells dropped as I was painting the profile and I had to complete part of it from memory, so it was just as well that I had studied the subject carefully first. This is all part of the enjoyment of flower painting, however, and I am sure that if flowers were permanent features of the landscape they would lose much of their appeal as subjects.

Fig. 82 Meadow cranesbill

Fig. 83 Foxgloves

Autumn

Autumn is my favourite season. It is so rich in exciting subjects for the artist: the leaves and seeds swirling in blustery winds; bright berries draped like strings of beads hanging jewel-like in the hedges; nuts nestling amongst piles of crisp, curling leaves.

Berries and nuts vary considerably in shape and colour and the surface of each type of berry is also quite individual. The hawthorn berry in **fig. 84**, for example, is quite a dull red with just a slight sheen, which I made by using Cadmium Red toned down with Burnt Umber and shading with a small brush to leave a little, soft-edged area of pale highlight. The snowberry has a dull, white, velvety surface, which I created by using soft blue and greeny-brown shadows. On the other hand, the small globules which make up the blackberry are quite shiny. I left crisp white highlights to achieve this glossy surface. The horse chestnut, or conker (**fig. 89**), resembles polished mahogany with very subtle lines like wood grain running over the rounded surfaces.

When drawing rounded objects in nature like berries, nuts, fruits, eggs and so forth it is worth remembering that they are all variations of the sphere. None is perfect and some depart quite radically, like the rosehip, which is elongated into a teardrop, or the conker, which swells into random lumps and bumps. The case of the conker follows the overall shape of its contents but erupts into sharp spikes, whilst the blackberry is a rough sphere made up of many smaller spheres. Once the basic form of the subject has been established you can then add these details of texture – the humps and holes, stems and stamens that give each object its unique character.

Look at the patterns made by leaves and the negative shapes left between them that are as interesting as the leaf shapes themselves. The edges of the leaves create an endless combination of curves, zigzags and scallops like those in **fig. 88**. I spent as much time composing these few sycamore and horse chestnut leaves into an interesting design on their white background as I did when drawing the whole thistle picture in **fig. 78**. I also painted the two subjects in a similar fashion, using masking fluid to block out around the shapes. As in the thistle painting the colours could then be flooded in to leave a crisp, hard edge when the mask was removed. At this stage I strengthened the colour in places, especially around the edges, and finally added the veins and stalks.

Autumn leaves come in such a profusion of rich, warm hues that you will probably need every colour in your palette to represent them. To paint those in **fig. 88** alone I used Raw Sienna, Yellow Ochre, Burnt Sienna, Purple Lake, Crimson Alizarin and Hooker's Green in various combinations.

Fig. 84 Hawthorn

Fig. 85 Blackberry

Fig. 86 Snowberry

Fig. 88 Sycamore and horse chestnut leaves

Fig. 87 Rosehip

Fig. 89 Conker

Fig. 90 Teazle

Winter

The qualities that attract me most about winter are those peculiar to the season: the strong, graphic images of stark, monochromatic bare branches; spiky teazles, spidery hogweed; and dried grasses against white snow or bare ground. Winter is the season of dark silhouetted images where the interest lies in shape and form rather than colour. Winter textures are also important – dry and brittle, hard and thorny.

The teazle (**fig. 90**) is especially typical of a winter plant subject, with its spiky hedgehog head and tendrils curling in elaborate loops and twists. If you look carefully at a teazle you can see that the positioning of these spikes is not just haphazard texture, but an incredibly intricate geometric pattern. When painting surface textures as fascinating as this it is important not to become so absorbed that the overall structure of the subject is forgotten. On both the teazle and the nest in **fig. 91** I was careful to note the direction of light on to the objects, which helps give them their roundness.

You may be surprised to see the inclusion of a bird's nest in the winter section – it might more usually be associated with the spring. All the paintings included in this chapter are of objects carefully picked and brought home to study at length. One would not, of course, take a nest during the months of spring and summer, but in winter the abandoned ones make wonderful subjects.

Both the nest and the teazle were painted using the same sequence of techniques that I have used in the rest of the book. First I washed pale colour over the shapes, gradually strengthening it as I progressed. The textural details were then added painstakingly, using small

Fig. 91 Abandoned nest

brushes to paint every line and dot purely because I sometimes like working in this slightly obsessive manner. The pale fine lines of grass and straw which make up the nest were achieved by painting the dark shapes around the lines, and the dark fine lines were painted with the point of a No. 00 brush. When painting with this degree of detail I find it helpful to use a smooth paper.

Objects like these would lend themselves very well to some of the creative techniques described earlier in the book (see page 22) as well as to the detailed style shown here. For example, you could paint the lines on the nest by drawing with a pen and nib and masking fluid, or by scratching lines out with a scalpel. You could make twigs and sprigs by blowing paint across the paper, or create the stippled seeds of dried grasses with a toothbrush spatter of dark paint. The results will be perhaps less accurate in photographic detail than those on these pages, but these techniques can be an expressive way of capturing certain quirks and qualities.

INTERPRETING YOUR SUBJECT

Fig. 92 Frosty winter hogweed

On these last pages I have taken one of my favourite subjects, the hogweed, and painted it several times in different ways, using the techniques described throughout the book. The point that I want to make here, however, has nothing to do with technique.

What I am trying to underline is the idea that I introduced at the beginning and reinforced in each chapter: that there is no definitive way of treating any subject. I can only describe how *I* might sometimes paint a tree,

for example, and give my reasons for choosing to do it in a particular way. I may also suggest other directions to pursue and give practical information and advice. Having digested this, however, it is then for you to consider what you have learned from this book and to select your own way of painting the subject.

Aesthetic decisions must be made before you even begin a painting. Decisions about tone, colour and composition, for example, all affect the mood of the

Fig. 93 Different interpretation of winter hogweed

picture. Look at your subject and decide what it is that appeals to you especially and then set yourself the goal of expressing this on paper. An onlooker should be able to look at your finished picture and ascertain exactly what interested you about the subject.

In my first version of winter hogweed (**fig. 92**) the bare stalks were bristling with frost. They made star-like patterns against a smoky blue and grey background, looking almost like children's sparklers on bonfire night. The second version (**fig. 93**) had a similarly brittle, linear quality to the first, but this time I knelt on the ground to look up at the dark stalks silhouetted against a pinkish sky. Viewed this way they acquired a wood-cut quality like that of the thistles in **fig. 78**.

These two paintings, although similar in subject matter, are completely different in mood – and a third picture could be different again.

Fig. 94 Summer hogweed

The aspect of the summer hogweed (**fig. 94**) that interested me was the lace doily effect of the flower heads against the gentle melting colours of a rainy day. Another version might show softly blotted-out flowers echoing the shapes of clouds in a deep blue summer sky. I am always aware of the different possible treatments for subjects I see on my country walks. Try looking at the countryside with a similar painterly eye.

The process of painting does not start when you pick up your brush and finish when the paint dries. Picture making is a way of life. We have constantly to look at and evaluate the things we see. Doing this gives me an enormous amount of pleasure and I hope that you will share this enjoyment in painting the countryside. Always remember that the whole point of the exercise is to do just that: enjoy yourself.